solace

A JOURNAL OF HUMAN EXPERIENCE

GENEVIEVE V. GEORGET

Writers of the Round Table Press

sol·ace
/ˈsäləs/

noun

*comfort or consolation in a time
of distress or sadness*

verb

to console; to give comfort to

PHOTOGRAPHY *Genevieve Georget*
COVER DESIGN *Christy Bui*
INTERIOR DESIGN *Sunny DiMartino*
COPYEDITING *Katherine Catmull*
PROOFREADING *Adam Lawrence, Carly Cohen*

Writers of the Round Table Press
PO Box 1603, Deerfield, IL 60015
www.roundtablecompanies.com

Printed in the United States of America

First edition: September 2019
10 9 8 7 6 5 4 3 2 1

Library of Congress Cataloging-in-Publication Data
Georget, Genevieve V.
Solace: a journal of human experience /
Genevieve V. Georget.—1st ed. p. cm.
ISBN paperback: 978-1-61066-078-5
ISBN digital: 978-1-61066-079-2
Library of Congress Control Number: 2019910174

Writers of the Round Table Press and the logo
are trademarks of Writers of the Round Table, Inc.

Dedicated to the wanderers, the wallflowers, and the wild soul seekers.

And to my dear friend, Marilyn, who has never let me walk alone, even in the midst of her own deep wilderness.

Prologue	1	106	*Life Lessons from Wildflowers*
What Would Your Sign Say?	7	108	*The Human in Me*
Fog	11	112	*Forming Scars*
Knowing	15	115	*The Dragon and the Wings*
Are You In?	23	121	*Perdure*
A Perfect Mess	27	124	*Reckless Love*
To the Sensitive Ones	32	129	*Final Credits*
Rush In	35	131	*Build*
Just Like Jazz	39	139	*Fake Is Easy*
Spring	43	143	*Mirrors*
Choose People Who Choose You	47	149	*This Is Me*
Right Now	51	152	*Don't Just Be Good to Others*
Human and Soul	53	155	*You Are Not Alone*
Be Love	57	161	*Messy*
Try Again	59	165	*Earthquakes*
Hide 'n' Seek	63	171	*Haunting*
The In-Between	67	175	*Greatness*
Write Your Own Story	70	181	*God Is in There*
To Be Someone	74	185	*Winter*
Old Tracks	79	189	*Real for You*
Please Stop	81	196	*Take Down the Walls*
This, Too	87	201	*Fall in Love*
Waiting	91	207	*Expectations*
My Biggest Fear	97	211	*The Israelites*
Doing It	100	215	*You Are Enough*
Walk On Water	103	217	*A New Year*

ACKNOWLEDGMENTS 221

BIOGRAPHY 225

ENDNOTES 227

INTRODUCTION

There was a bit of debate for a while over the subtitle of this book.

A Journal of Human Experience or *A Journal of Human Vulnerability.*

Our editorial team had a lively discussion, and I took to social media to inquire about other people's thoughts.

I'll admit that it was something that I had to sit with for a while. I was bouncing back and forth between our various words, taking in everyone's feedback and praying about which one felt the most "right" for me.

And the whole debate made me think about a dance that our kids' school recently held . . .

Here was a school gym: music playing, colored lights glowing, decorations, a group of kids in the middle of the room, dancing their little hearts out . . . and all along the walls, dozens of other kids scattered about, staring longingly at the ones who were all in.

Wallflowers.

So often singled out for not dancing amid the crowd, and all the while they still had the courage to show up. That's what I love most about wallflowers: their silent bravery.

I have the unique privilege of leading an online community of people who join together to celebrate a mutual love of words, storytelling, and supporting one another through life. It feels like a ministry in many ways. And when I reached out to that community to ask which word they preferred, the resounding answer from those who answered publicly was "vulnerability." And yet, when I stopped to take notice of those who were speaking up, I also noticed that they were the people in my life who naturally crave vulnerability . . . speak vulnerability . . . and live vulnerability. They were the kids who are always dancing.

At the time of writing this, our community was thirty-five thousand beautiful humans strong, and while about five hundred of those people will graciously share their voices with us on any given day, the majority of those people are actually wallflowers.

They sit quietly in the shadows. They watch from a distance. They slip out the door before anyone else.

But here's the thing . . .

They still have the courage to show up.

And my inbox was flooded with messages from them about how scary or painful the word "vulnerability" felt to them.

"I reached out to someone in vulnerability, and they rejected me."

"I spoke up in vulnerability, and everyone laughed at me."

"I showed my vulnerable side, and I got labeled 'too sensitive.'"

My observation, across the board, was that the word "vulnerability" came with a predetermined emotion already attached to it: raw, empowering, isolating, fearful, honest, difficult.

But the word "experience" seemed to allow space for whatever emotion might come. It was an invitation to the party even if you didn't feel comfortable enough to dance.

A client of mine once said to me that the best way to connect with people is through compassion, and that the key to compassion is remembering that you weren't always the person you are now.

I spent thirty-five years being a wallflower. I spent thirty-five years admiring people's courage from a distance. Because it's scary to put yourself out there. It's scary to stand in the middle of a gym and dance with reckless abandon. It's scary to step away from the wall.

Especially if you've never done it before.

BUT, if you show up to the dance enough times, you're bound to join in eventually. That's why you go. Because, deep down, you want to be there.

And when it does finally happen, you'll realize that no one really thinks they have good moves. You'll realize that everyone is a little bit afraid. You'll realize that there is enough room on the dance floor for all of us.

I may be standing front and centre now, but only because I was invited to a hundred parties before that, where it was okay for me to stand quietly on the sidelines.

Ultimately, here's what it comes down to for me . . .

Consider yourself invited. Even if you don't want to dance.

xoxo

Trust me when I say that you don't want to see me right now.

It's January 1st. My hair is disheveled. My eyes are bloodshot. My feet are blistered and sore. My nails are dirty and cracked. My skin is scratched, and my shoulders are hunched forward. My muscles feel worn, and my soul feels even worse.

It's all I can do to keep my eyes open right now. I just want to curl up under the down blankets of my bed and sleep for months. I want to listen to wind blow past our windows and just drift for a while until all of the little cracks inside of me repair themselves.

I've just spent a number of months walking through the desert. It was a walk that I never expected to take and a walk that both shattered me and healed me, all at the same time.

I've seen the desert before. My husband and I sat in a compact car with the windows down as we drove from Las Vegas to the Grand Canyon. Small desert towns passed by, and tumbleweeds rolled off in the distance. The neutral palette of colors struck me, as one tone just seemed to blend in with the next. I had my elbow resting on the edge of the window, and my hair was endlessly blowing across my face. But I couldn't stop staring out. At what, I wasn't sure. But something was out there, among the sand and the rocks and the way that the sun set, which seemed entirely unique to this place. I could feel it.

The sun beat down on my husband's side of the car, falling just across his arm and face. I could see a reflection of the road ahead in his sunglasses, and while we didn't say much throughout the drive, he would look over at me every once in a while and squeeze my hand, almost as though checking to make sure I was still there. I would look over at him and smile . . . he would smile back, and we'd keep tackling the long road ahead of us.

The desert is full of long roads.

Four years earlier, we found ourselves in the Australian outback, driving from the small town of Alice Springs to the site of Uluru. The sand was so red that it stained our shoes for weeks. You could actually see the heat radiating off the highway as semi trucks passed by you at incomprehensible speeds. We drove for five hours without passing a single vehicle, and I remember how conflicted I felt being in this place; it felt like both the most desolate and the most beautiful thing I had ever seen. Vultures could be seen for miles ahead as they circled dead animals off the side of the road.

What I remember thinking in both places, though, was that there was nowhere to hide out there. The landscape just extended to the ends of the earth, and the sense of vulnerability was inescapable.

When I was a little girl, I actually romanticized the idea of the desert, this vast wilderness. I always thought of it as this immense terrain that seems so barren by day, so filled with endless stars at night, and that those long stretches of road possessed everyone's stories. The dark, the loveless, the mysteries that we all wanted the answers to. I craved this kind of mysterious infinity.

But walking through an emotional desert felt so different.

This was a deep desert of the soul. The kind that brought loneliness and doubt as far as the eye could see. It was a place that left me with all of my darkest fears and all of my most vulnerable truths. It was the place that offered nowhere to hide.

And maybe that's the point. Maybe we become so accustomed to hiding behind our smiles and our careers and our possessions that the only thing left for God to do is to bring us to a place stripped of all of our comfortable hiding places, until we realize that the only way out . . . is actually through.

Through facing all the broken pieces of yourself.

And it was here, in this place of isolation, where I found what I had been looking for all along . . .

Myself.

But it didn't happen the way I expected it to. It didn't happen with the magic and mystery that I imagined as a kid.

It happened with surrendering a belief that I had been carrying around with me for far too long: the belief that I had to become someone different from who I already was.

We live in a time that often asks us to pick sides. We are asked to cross lines and stand tall and believe that all of our answers can be wrapped up in perfect little compartments. But somewhere, amid the terrain of that wilderness, I learned that being human doesn't fit in a box. At least not for me. A large part of my struggle in this life was because my spirit couldn't fit into an all-or-nothing experience.

I could love people but not like them.

I could want something but be afraid of it.

I could move toward chaos but do so with stillness.

The road I walked as a human wasn't a black-or-white reality. It was very gray. And accepting these blurry lines became the gateway to a whole new truth about who I was: a person who wasn't just one or the other but rather someone who fell on a spectrum that borrowed from a bit of both.

But I also struggled to tell that truth because I believed that showing the cracks in my armor made me less equipped for battle: less lovable, less reliable, less worthy of claiming my space in this world.

But again, as the elements wore away at my rough edges, I began to learn that the truth feels like a rare thing sometimes.

In a world filled with filters and status updates, the raw truth often stands alone in a culture of curated reality. And we think this is what we need to be accepted—a degree of perfection to stand out amid the crowd. All the while, the more polished our lives seem to be, the more insecure we tend to feel.

But we aren't made of filtered fiction. We are made of solid truth.

Our truth makes mountains and continental cores and gives us something solid to stand on.

Our truth matters. And our truth is strong.

Acknowledging my truth meant acknowledging my history and my tension and my deep-seated insecurities. It meant acknowledging who I am, who I am not, and who I hope to become. And it meant acknowledging that my strength didn't lie in who others needed me to be but rather in the person I've always been.

It wasn't the road from Vegas or the vast horizons of the Australian outback. It wasn't the dark, the loveless, the mysterious infinity.

It was me and God and the demons that reside in the dark corners of my mind. It was the excavation of a life that not only looked good on the outside but felt good on the inside. It was hard and messy and painful.

And it was the best thing I've ever done.

I recently passed a guy on the street while I was walking downtown. It was desperately cold and the ground was icy. He was wrapped in a blanket and curled up in the corner of two brick buildings. He had a sign leaning against him made from a cardboard box and a little Styrofoam cup with remnants of change sitting at the bottom. As I got a bit closer, I could finally see his sign; in scribbled black letters, it said, "I don't care about food right now—I need to get high. Thank you." I slowed down a bit, and, in that moment, my eyes must have deceived me because he leaned his head toward me and quietly said, "I know, it's not what you expected, right?"

"I guess not," I responded.

"Well," he said, "I could tell you a truth that's painful and ugly, or I could tell you a lie that deceives us both."

As the words lingered in the air between us, something inside of me began to physically ache.

Because, right there—on the side of the road, buried under a pile of blankets—sat the courage that I had been struggling to find for so long.

And it made me wonder: what would it look like if we all held up our own signs full of truth and vulnerability? What would they say?

This wilderness that I'm telling you about? This long walk that I'm taking in the midst of uncertain territory?

I notice that the further I go, the deeper I get. Filled with more doubt, asking more questions, and feeling more distant from God.

And if I borrowed from the bravery of a man lying under a pile of blankets on the side of the road, my sign would say:

> I'm scared. I'm anxious. I'm nervous.

> I feel as though I were led out here, only to be abandoned.

> And I'm trying really, really hard to find my way.

I bent down and chatted with this man for a while. He told me that sometimes he uses his money for drugs, other times he uses it for books. That day wasn't going to be a book day.

He wasn't shy about his pain. He wasn't cautious about his vulnerability. He wasn't glossy about his struggle.

It was just him and his truth, sitting out in the middle of a cold, urban wilderness.

There are many of us enduring rough terrain right now. I know because you've told me. I know because you've reached out. I know because you've courageously held up your own scribbled signs showing me your own painful truth.

You're hurting. You're scared. You're heartbroken. You're struggling.

And I need you to know that I hear you. I see you. I feel you.

I also need you to know that I am very much one of you.

You are not alone in this wilderness. None of us are.

But I know that it's easy to feel alone.

So, today, I want to raise all of us up in prayer. Because while I certainly don't know what to do next, I know a Guy who might . . .

For those of us in the midst of a seemingly endless wilderness: I pray for stamina and hope and guidance. I pray that our peace runs wide and our wisdom runs deep. I pray for comfort and love and sleep-filled nights. I pray that our wounds be healed, that our fears be tamed, and that our faith be strong. I pray that our paths be made clear.

And most of all, these signs we are carrying—I pray that we always have the courage to hold them high.

Because, while the truth may be painful and ugly, it's the lies that deceive us all.

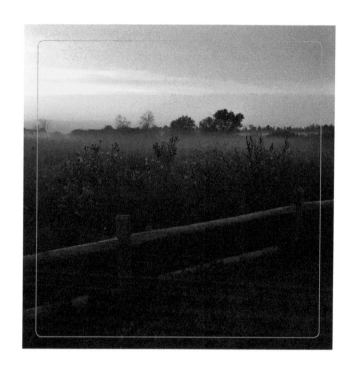

The early morning fog outside of our house always takes my breath away. It's so dense and yet so hauntingly beautiful at the same time. And it always brings a unique type of cold with it, the kind of chill that reaches down into your bones and not just your skin. I never quite feel like myself in the fog. Every sound makes me little bit nervous, and my instinct is to just stand in one place.

Doesn't the fog seem so heavy sometimes? Don't you stand there sometimes and think to yourself, *I remember. I remember when I could actually see in front of me* . . .

It can feel so unsettling to stand within the uncertainty and not see where you're going. It can feel uncomfortable to watch the view disappear before your eyes. It can start to infuse a fearful chill right down your spine and make you scared to take another step forward.

I catch myself standing there sometimes. Maybe you do too.

And yet.

And yet . . .

We know that everything is still there. The horizon, the earth, the ground beneath our feet.

It isn't gone. It hasn't vanished. It hasn't left us all by ourselves.

Our view has simply been altered by temporary conditions.

That's all.

Say it with me . . .

"That's all."

And, honestly, I've never met a fog that didn't lift . . . that wasn't burned away by the radiant warmth of the light.

But, in the meantime, deep down, we have to remember that everything is still there.

We may want an extra blanket to keep the cold away . . . and it may feel a little bit scarier than usual . . . but it's okay.

The road ahead of us is still there.

But we'll have to take a first step in order to really know for ourselves.

Here's to stepping out into the fog . . .

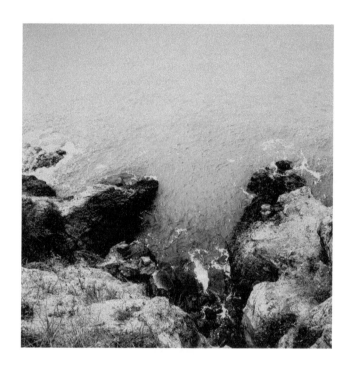

Looking back, I wish that someone had been there with me. I wish that someone had gently put their hand on my arm as I went to pick up the phone and quietly whispered, "Wait . . . just one more minute . . . because what's about to happen will hurt more than anything has before."

It was the early morning hours of a long summer night, and I held the phone in my hand as the words made their way from one end to the other . . .

"Gen, I need to tell you something . . ."

There haven't been a lot of moments in my life when I've actually felt myself change. But this was one of them.

And I remember exactly how it felt.

I remember exactly what time it was, and I remember exactly how the rain sounded as it hit the outside of my bedroom windows. And I remember exactly what it was like to feel all of the air leave my lungs.

As I sat silent in my bed. As my fingers struggled to hold the phone in my hand. As I wondered what all of this was about to mean.

Something changed.

Something inside of me began to shift . . . to alter . . . to split open.

It's always hard when relationships break. It hurts. But it hurts even more when it breaks at the hands of dishonesty. And sometimes, you become filled with emotions that don't belong inside of you.

Torment. Confusion. Resentment.

This storm builds inside of you as you slowly try to piece together where things suddenly went wrong.

And wanting to know the truth often becomes the missing piece that we desperately try to hold onto in the midst of all the pain.

When did the lies start?

How did I miss them?

What really happened?

If I were to be entirely honest, I want to be able to tell you that I was completely justified in my hurt and my anger. I want to be able to tell you that I was blindsided by the betrayal of it all. I want to be able to tell you that somewhere between there and here, I was able to recognize that I was simply collateral damage in someone else's emotional collision.

But I can't tell you those things.

The only thing that I can truthfully tell you . . . is that I knew.

I knew when things first started to feel distant. I knew when I sensed that there were things I wasn't being told. I knew when the tone of their voice didn't match the words in their mouth.

I knew.

I knew where all of this was going, and I knew how it would end. I knew where I would be left, and I knew who I would be. I knew how it would feel, and I knew what it would do to me.

I knew.

We often do.

But our hearts . . .

Our sweet, vulnerable, tender hearts.

They want to be seen. They want to be chosen. They want to be felt.

And they want to matter.

I wanted to matter.

And so I lied.

I lied about my feelings, I lied about my insecurities, I lied about my needs.

I lied to myself about what was really happening.

I think there are various times in our lives when we don't always know who it is that we want to be. During those times, instead of running toward who we are, we fight to move away from the person we don't want to be.

I didn't want to be the person whose heart wasn't seen. Whose heart wasn't chosen.

I didn't want to be the rejected one, the insignificant one, the disposable one.

I didn't want to be the person that was left standing alone.

And so I pushed aside the nagging feeling that comes with "knowing" in exchange for more "giving": more time, more love, more words. All the while hoping that the truth might change.

But it didn't.

Instead, I was left in the middle of the night with a depleted soul and a brand-new truth . . .

The truth being that you are capable of breaking your own heart in ways that no other human being can.

And that's what I had done.

I had lied to myself. I had betrayed myself. I handed myself over to someone else's story in the hopes that I could rewrite the inevitable ending.

I did all of this until I became a hollowed-out shell of a person, standing alone, with only one thing left to do . . .

Forgive myself.

Even now—nearly twenty years and an entire world later—when I stop to look back, it sometimes feels like the act of forgiving myself is a conscious choice that I have to make all over again.

Because even in the midst of your current light, it's hard knowing the darkness you once allowed yourself to live through.

But if you are in this place right now, if you willingly got into an emotional vehicle that you knew would crash, if you are suffering from any kind of self-inflicted wounds, please do this one thing for me . . .

Go to the nearest mirror. Look yourself in the eyes. And repeat after me . . .

"I'm sorry."

Stand there and say it over and over and over again until you start to believe even a fragment of it. Say it until the person staring back at you starts to look a little more familiar. Say it until you start to feel a little less hollow and a bit more human.

And know this . . .

It's okay.

It's okay that you fought harder for someone else than you did for yourself.

It's okay that you believed in who a person could be instead of who they actually were.

It's okay that you knew a relationship would hurt you but chose to hold on to it anyway.

It's painful and it's hard and it's all-encompassing at times, but it's okay. Because that's how you'll end up knowing something even more important . . .

You'll know just how much your heart is actually worth. You'll know just how strong your spirit really is. You'll know just how loud that voice inside of you can really be.

And you'll know that while no one can break your own heart as much as you can . . . no one can put it back together as well as you can, either.

I believe the universe is most often this beautifully gentle force, luring us in the direction of our dreams. It takes us by the hand and whispers in our ear. It slowly draws us out and brings us close. And other times, not so much! Other times, you get slapped upside the head with the delicate touch of a wrecking ball so you can be reminded of who you're really dealing with here: the universe! The ultimate risk-taker, the expert dream-maker, and one hell of an ass-kicker!!

The thing of it is, though, I don't believe the universe waits around forever. I believe it finds you, it calls to you, it invites you, and if you say no or sit around waiting for the "ideal" time, the universe is going to move right along and find someone else a bit more willing. Because the universe isn't messing around here. It isn't interested in wasting time or weighing the odds. The universe has stuff to do; it has art to make, people to save, lives to inspire.

So it's our decision: get on board, or step aside. But either way, the universe is hiring and the magic is happening.

With or without us.

As the sun rises or sets wherever you are today, let's sit with this one life-changing question.

Because the decorations are up, the music is playing, and I'm told it's going to be a really great party.

Yes, we may feel a bit shy. Yes, we may not know what to wear. Yes, we may drink too much spiked punch and do some really ridiculous things.

But the universe really wants us to go anyway.

That's why I think it's time.

It's time to quiet the noise in our heads. It's time to settle the fear in our hearts. It's time to RSVP to the best invitation we're ever going to get!

Three little words. One big question.

So what's it going to be . . .

Are you in?

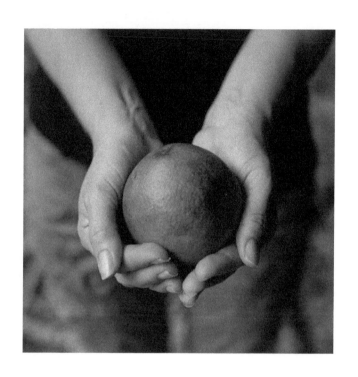

It was an orange. That's all. An orange.

It was an orange that a cute teenage boy handed me on the back of a tractor as we were making our way through the mountains of Belize.

"Try it," he said. "You'll love it."

I looked at the orange. I looked back at him. And he gave me one of those smiles that only a cute teenage boy can. The kind that said, *Don't worry . . . trust me on this one!*

It had all started four days earlier when a group of strangers descended upon a gorgeous villa in the tiny town of Hopkins, Belize, for a week-long women's retreat. We arrived at all hours of the night and came from every different direction.

We were all there for different reasons, but the reasons didn't really matter. What mattered was that we were there.

What mattered was that we had taken time off of work. We had dug into our savings accounts. We had left our spouses to single-parent our children.

And while all of those things might have felt a bit uncomfortable at the time, we did them. We did what needed to be done to bring us to this place. And that's what mattered. Because, so often, we don't do those things. So often, we *know* what we need in order to thrive, to feel healthy, to chase our dreams. But those things get buried under a pile of bills, homework, business assignments . . . until eventually, you're left staring at a teenage boy, wondering if he's trying to trick you into eating poisonous fruit!

So that's how I ended up with the orange: we were making our way through a grove, and this boy picked it off the tree and threw it across to me, radiating pride as we fell in love with the scenery.

But when he suggested I try the orange, I wasn't so sure.
I glanced over at one of the other girls and felt perplexed.

Normally, I would eat an orange if someone handed it to me.

But this orange didn't *look* like it should be eaten. This orange was tough and all discolored. This orange wasn't really orange at all. Honestly, at first glance, I assumed the season had passed and these were leftover fruits, rotting on the tree.

I looked up at our guide again, and he laughed under his breath. "I promise . . . they're good!!" he assured me.

And as I sat there peeling away at this orange in the middle of the jungle, I had to wonder, How many times had I judged myself the exact same way? How many times had I questioned my own internal goodness because I felt flawed on the outside? How many times did I worry more about showing the perfect outer layer than an inside that mattered?

The truth is, more times than I would like to admit.

Because somehow, I had come to believe that if I could get the outside "right," then no one would notice the inside.

I had come to believe that if I were to vacuum my house enough times a day and ensure my hair looked decent and put the right filter on my Instagram photos and finish those cupcakes on time for the school party and workout six times a week and never eat anything with refined sugar in it ... *and and and* ... if I could just do all of that, then maybe no one would notice just how messy everything was on the inside.

And messy can feel scary for me. Because messy means admitting that I sometimes feel like the only person in the world who doesn't have everything figured out. It means admitting that I have absolutely no idea what I'm doing most of the time. It means admitting that—even with an online community of thirty-five thousand people—I often struggle to feel like I belong. It means admitting that, sometimes, all I really want is a chocolate chip cookie and a nap instead of going for a run.

But admitting these things also made me wonder: if the quest for perfection is my new sickness, could peeling back the layers be the cure?

And we did a lot of that in Belize. We did a lot of baring our souls and feeling exposed. We did a lot of truth-telling and tear-shedding. We did a lot of falling to our knees and raising our hands to the stars.

And you know what?

There was no judgment. There was no rejection. There was no advice on how to make the outside prettier.

Instead, there was a big pile of messy things in the middle of a room and a bunch of people who didn't feel so alone anymore.

Also, I ate the best orange I've ever had in my life!

It dripped down my arms, the peel stained my fingernails, my hands were sticky, and it was perfect! It was a mess and it was perfect.

And so it is with life.

Because life is messy. All of those struggles and feelings and insecurities are messy. Relationships are messy. Being human is messy. Working through it all is messy.

And it's also perfect . . . in its own imperfect way.

But I realized that, if I'm too busy trying to perfect the outside, then I miss the opportunity to be messy with other people. I miss the chance to throw my own stuff in the pile and witness what a beautiful mess it all creates. I miss the moment to peel back the layers and discover that I'm not alone.

I realized that I could have missed the best orange I've ever had in my life.

I see you.

I see you with your shoulders hunched forward and your eyes filled with doubt.

I see you as your mind starts to race and your heart starts to hurt.

I see you standing in front of someone else—a loved one, a colleague, a friend . . . while they unleash the words that pierce right through you . . .

"You're just a little too sensitive."

I see you slowly take a step back and quietly shut yourself down.

I see you as the words linger in the air and begin to soak through your skin.

And I see you as it starts to happen.

As you start to let the question spread through your bones . . .

"What if they're right?"

I'm here to tell you that they are right.

You are too sensitive.

I am too sensitive.

We are too sensitive.

We're too sensitive for a world that doesn't know how to handle vulnerability. We're too sensitive for people who don't want to have uncomfortable conversations. We're too sensitive for a culture that measures strength by the number of tears you refuse to shed.

But we're not too sensitive for each other.

And furthermore, our sensitivity is not a liability.

Because, in a world that is becoming more hardened by the minute, that sensitivity is a gift. In a society where everyone is building brick walls around their hearts, that sensitivity tears them down. In a life that is being driven by success, that sensitivity takes the wheel with love.

Please believe me when I say I make this next statement for myself just as much as anyone else who might need to hear it . . .

It's okay to be emotional. It's okay to experience your feelings. It's okay to show up as your whole self, regardless of how messy that might be.

And if people try to tell you otherwise, then those aren't your people.

That's okay too.

Because this life is filled with people who feel the world in a very deep way. It's filled with people who hand over vulnerability in the name of connection. It's filled with people willing to sit through the discomfort of the human experience so others don't have to.

And if you're out there right now, feeling rejected or isolated or misunderstood, I'm here to tell you one last thing . . .

I see you, and I hope you never change.

I read recently that, as humans, we are more afraid of joy than any other emotion. We fear it because we know that we can lose it, and loss of something is more traumatic to the human consciousness than never having acquired something in the first place. The irony of this is that our greatest goal as a species is to experience life. But that breadth of human capacity terrifies us. And so we shut down. We break down. We remove ourselves from the moment so that we don't risk losing it.

Joy is, and always has been, a struggle for me.

Even as a young child, I found myself hypersensitive to how easily life could just slip away, the same way sand slips through our fingers. And it scared me. It always has. And in the brief moments when I would find myself lost in joy, it would quickly happen, this panicked feeling of waiting for the other shoe to drop, for the sadness to finally kick in, for the reality of this broken world to land at my feet. I've never felt comfortable getting too attached to the feeling of joy.

I understand that this is a protective coping mechanism, put in place a long time ago by a little girl who just wanted to feel safe. Anyone who knows the inner workings of chaos understands that self-preservation is a very real thing. But I'm wondering if there comes a time when those coping mechanisms don't really serve us anymore, if we can learn to let go and allow the universe to hold us.

Because I don't want to be so busy protecting myself from life that I forget to live it.

I had a friend come to visit me recently for a weekend. She flew over from the Pacific Northwest, and we had fifty-six glorious hours together of drinking coffee, sharing bottles of wine, getting lost in conversation, and laughing until we cried. It was time I didn't know I needed until I was sitting in the midst of it. It was time I didn't realize I would miss until I was driving away from it.

It was time filled with joy.

The sun was only just rising as I headed home after dropping her off at the airport. I could see it peeking up over the horizon, and in a single incredible moment, the light of day rushed through the trees. There was an exquisite stillness to it that I hadn't felt in a while. I pulled over on the side of the road for a bit, and as the beauty was unfolding, I realized something . . .

Yes, it's fleeting. All of it is.

The good and the bad. The joy and the sadness. The light and the dark.

This moment, this beauty, this experience.

And it scares us, the temporary feeling of it all.

While we're powerful and strong and capable of amazing things, we're also just small children wanting to know that everything's going to be all right.

And that's okay.

I think it's one of the most beautiful parts about being human.

And as I sat there, in the early morning hours of the day, I suddenly felt overcome with one single thought . . .

Let's rush in.

Let's rush into our lives the way the light rushes through the trees.

Let's travel the world and discover our country and roam our neighborhood. Let's smile at strangers and make new friends and show kindness as often as possible. Let's open ourselves up . . . and pour ourselves out . . . and let others in. Let's love one another. Truly, madly, and deeply. Let's look up at the stars and realize what an incredible miracle we are. Let's put photos on our walls and memories in our hearts. Let's laugh together and cry together and split wide open together. Let's turn our lives into stories that our grandchildren will share. Let's honor one another's lives and the roads that have been walked to get there. Let's raise one another up and stop tearing ourselves down. Let's chase big dreams and take big risks and face big fears. Let's replace guilt with love and comparison with grace.

Let's find the beautiful thread that ties everything together and follow it till the end.

Let's rush into that joy and be grateful that it's happening.

Let's belong to one another.

Let's rush in.

I get a lot of emails.

Usually they are emails about relationships.

About people who meet at vulnerable times, in vulnerable circumstances, with vulnerable hearts.

About people who are connected in ways they don't entirely understand, in a world where they don't entirely belong, with feelings they can't entirely describe.

About people who are struggling over a relationship that they can feel, but they can't quite have.

And I often get asked how I feel about this type of connection, these types of people that impact our lives in such inexplicable ways.

And, honestly, I believe that what is shared between two people is so personal and so intimate that I could never presume to know a thing about any relationship that isn't my own.

But every time I get one of those emails, an email that has a heart poured out over a person so loved . . . it makes me think about jazz.

I was in Vancouver, British Columbia, when I walked into a bar one evening, only to find this tall, dark-eyed gentleman playing the most beautiful grand piano. Hair all disheveled. Motions flawless. Voice intoxicating.

We stood there, a group of strangers, shoulder to shoulder, in this dimly lit room while the melody filled the air.

The feeling I had when I first listened to this music was unlike anything else I had experienced before. A sense of comfort settled into my bones, as though this music had been a part of me all along.

The thing about jazz is that I don't really know anything about it. I don't know its history or its evolution or the struggles that it might have endured over time. We are unfamiliar to each other in that way.

When I listen to jazz, I don't know who's playing it or what the song is called or which album it's from.

And, to be completely honest, I don't really care.

All I know is that when I listen to jazz music, I feel connected to it. As though we somehow belong to each other, from another time or another place, reaching out our hands across parallel dimensions.

I don't need to dance to jazz music. I don't need to sing to jazz music. I just need to *be* with jazz music. I also don't listen to jazz all the time. But I also don't need to. Because, oftentimes, just knowing that it's there is enough.

Enough to calm my soul. Enough to fill my heart. Enough to soothe my spirit.

The intimacy of it all is something I simply can't explain.

I also can't explain the intricate ways in which the universe sometimes brings us together. I can't explain the best way for us to maneuver the connections we have with other people. I can't explain how to manage the emotions that are found in the space between love and loss.

But I do know one thing . . .

Some people end up walking into our lives . . . and they feel just like jazz.

I was driving today when a song came on that reminded me of a specific person. We were friends for a while, until we weren't anymore. A conflict happened, the relationship was lost. And sometimes, I miss them.

The violin playing during the second half of the chorus is one of those times.

I used to think that I was good at friendship. I used to think that I had something to offer. Until someone told me that I was a bad friend and I allowed myself to believe them. Until an avalanche of hurt soon followed and buried everything I thought was true about myself. Until I let seeds of self-doubt slip between my fingers and cover the ground beneath me.

Eventually, time passed and the seasons changed—like they always do—but those seeds began to grow and weeds began to rise. Those weeds slowly wrapped themselves around my limbs and, eventually, they tied me to a new truth, the one that said I had fallen short of being enough.

Pretty soon, I simply counted each one these weeds as a mark of failure on my part. A mark of inadequacy. A mark of rejection.

I have struggled to navigate my way through friendships ever since. I have struggled to stand strong in them. I have struggled to trust them. I have struggled to believe that I deserve them.

I felt tangled in a mess of everything I couldn't make right, and I treated these weeds like they were chains—never letting me move, never letting me step forward, never letting me walk away from the pain.

When others were done punishing me, I had simply picked up where they had left off, tied to a failure I thought I deserved.

And it made me wonder: how long can any one person remain entangled in a truth that someone else has handed them?

But then, there's this time of year . . .

That time when the ground is thawing and the earth is rising. That time when the temperature is warm but the air is still cool. That time when it's not quite winter but it's not quite spring. It's vulnerable and messy and raw. It's the time of year that makes my emotions run wide and my memories run deep.

It's also a time of renewal, of growth, of claiming your rightful place in this world. It's about rising from the ground and standing tall in honor of who you have fought to be.

It's about changing.

I've decided that I would like my spring to be about untying myself from the weeds that have held me hostage for so long, about forgiving everything I was never able to be, about hearing that beautiful song and knowing that I did the very best that I could with all that I had.

Because, in our human frailty, we will end up failing others. But when we don't set ourselves free from someone else's truth, we will end up failing ourselves.

Friendship has been one of the biggest challenges I've had to face in my deserted wilderness.

I was a very shy little girl. I was an only child, and I was acutely aware of my "only-ness." From a very young age, I felt like friendship was a game and I didn't know the rules. So I simply kept to myself.

I was blessed with a couple of beautiful friends during high school. Sadly, those were also some of the hardest years of my life, which made investing in those friendships a difficult task.

I was suffering from an eating disorder, my relationship with my mother was falling apart, I had been sexually assaulted by a person I trusted, and my home life was unbearably toxic.

By the time university came along, I had endured enough to believe that people weren't worth trusting. My years in university were spent knowing people four months at a time, based on who I shared a class or an apartment with. I moved from one year to the next with very little attachment.

Having said that, I was a great rescuer.

Give me your broken pieces, and I'll give you what's left of my soul.

I thought if I could fix everyone else, my own fractured self would get healed along the way.

I came to discover that life doesn't really work like that. No amount of sacrifice to someone else's pain would lessen my own deep wounds.

Trust me, I've tried.

When I did eventually find the strength and the courage to look at my own bleeding heart . . . here's what happened . . .

My heart had changed, but it was still pretty scared of other people. It was still afraid of being rejected. It still wanted to hide from any potential hurt.

And because of this, I got so consumed with trying to BE a good friend . . . that I didn't really notice if I HAD a good friend in return.

In case you're wondering . . . this realization hurts.

A lot.

But it also moved me to become much more intentional about friendship. To pay attention. To notice. And for the first time in my life, to select.

I'm not going to lie. This was hard.

When you've been driven by approval and acceptance, putting on the brakes can make your flesh physically ache.

I took steps back from people that I thought were close friends. I opened my eyes to notice people who weren't really friends at all. And I sat through a lot of really uncomfortable feelings again.

It was lonely and painful and involved a lot of grieving in various ways.

It still does sometimes.

But I had spent so much of my life just wanting to be chosen, that it never occurred to me that—I too—got to choose.

I was allowed to choose people whom I could trust. I was allowed to choose people who truly cared. I was allowed to choose people who would support me as much as I supported them.

I was allowed to choose people . . . who also chose me.

And that doesn't mean that every friend will last a lifetime. It doesn't mean that there won't be challenges along the way. It doesn't mean that you won't get hurt in the end.

It means that you're worth something.

Your friendship is worth something.

Your beautiful heart is worth something.

So choose people who choose you.

Look, I know that you're busy and that the world requires a lot of your attention, but before you take another step further today, I need you to do something for me.

I need you to stop. Right where you are.

I need you to look at the ground beneath you. I need you to look at whatever people might be surrounding you. I need you to notice the light that is falling upon you.

I need you to notice. Because this is your life.

It may look different than you expected right now. It may be exceptionally hard right now. It may be better than you ever thought possible right now.

But it's still your life. Right now.

And this very moment . . . in this very spot . . . is where anything can happen.

Right now, is where magic is created. When you finally make that phone call . . . write that letter . . . or reach out that hand.

Right now is where peace is sought. When we say, "I'm sorry" . . . "I forgive you" . . . or "Let's move forward."

Right now is where freedom is found. When you whisper to yourself, "The punishment is over" . . . "It's time to go" . . . or "I'm allowed to be happy."

Right now alters lives . . . heals hearts . . . and births dreams.

Notice it . . . because you're making a choice about what to do with it.

Right now is what you've been waiting for. Right now is happening right before your very eyes. And right now is all that we've got.

So when I say that I need you to do something for me . . . what I'm really saying is that I need you to realize something for yourself . . .

Because right now . . . can change everything.

I once read an article about a group of scientists who believe that all of us have people in this world that we are drawn to on a cellular level. It's different from attraction, different from friendship, different from love. They say it's often something that we don't understand, something that we can't explain, something that we can't control. These scientists believe that, when we are far apart or unaware of these people, life tends to go on seemingly unaffected. However, if we suddenly find ourselves in the other's life or become in closer proximity to them, a tension arises, a great force that leaves both people feeling a sense of restlessness and dis-ease. The closer those cells come to each other, the closer they need to be. And so they pull.

These scientists believe that these people aren't necessarily connected through physical presence or the maintenance of a relationship. They simply *feel* each other on an energetic level.

Like two souls, reaching out through the vastness of the universe.

It's both a wonderful and terrifying thought.

I believe, when we pay closer attention, we can begin to notice this force at work: that person that you think about, and then suddenly you receive a phone call from them; that person you've had a dream about and unexpectedly bump into on the street; that person that doesn't say a word, and yet you know that something is wrong.

But it's also believed that these people can experience great unexplainable conflict between one another. Mostly because— on some level—these people make us feel afraid; we begin to fear the unknown. We become afraid of what they see. Yet we also become afraid of not having them in our lives. We seldom understand it, but we almost always *feel* it. And so we push.

Like two humans, backing into a dark corner, fiercely trying to protect themselves.

Really, it's just the great tension of life: the desire to move toward something and the need to run from it, the instinct to care about someone and the impulse to save ourselves from them.

The pull and the push.

The love and the fear.

The soul and the human.

These two parts of ourselves desperately trying to coexist.

I spent a really long time trying to avoid this tension, trying to avoid the swinging pendulum that comes with being two halves of a whole. I believed that if I could deny my soul, then I would have an easier time being human. I just didn't want the pain of being pulled in opposite directions. But then I, in doing so, realized that I didn't get to experience that divine force that brings some of us together, that I would miss out on those people that the universe intended me to care about, whether I understood it or not.

But it can be hard to honor our souls while we're busy being humans. It can be hard to be honest about the fears that sometimes come with caring about other people. It can be hard to start on a path that you know might end in pain.

My soul doesn't want to hide from you. But my human is afraid of being hurt by you.

I'm slowly starting to learn, though, that there is a safe place in all of this. And we don't get there through stepping aside; we get there by stepping *in*.

Into the space. Into the tension. Into the beautiful chaos.

Love people. Lose people. And let yourself land gently in the truth that is left behind . . .

If we're going to be a part of other people's souls, then we have to risk being human to get there.

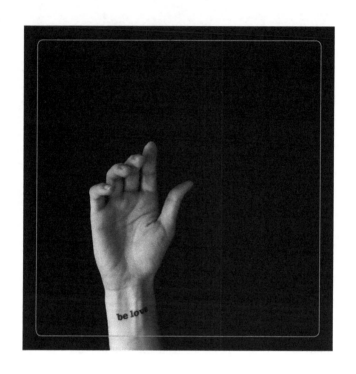

It's an exquisite thing to be moved by people. To witness their humanity and have them bear witness to your own. Of all the things to fight for in this world, I believe there is nothing more worthwhile than fighting for each other. For that place of witness in each other's lives.

It can be hard, though.

When our pain feels raw, when our insecurities feel exposed, when our hearts feel forgotten.

We become fear.

And fear shuts us down. Fear rips us apart. Fear hides us away.

Fear fights for itself.

For the pain that it conceals. For the pride that it carries. For the shame that it feels.

But love.

Love breaks open. Love holds strong. Love stands tall.

Love fights for each other.

For the story that it tells. For the truth that it shares. For the space that it holds.

Love fights for the chance to witness.

Even when it's hard. Even when it's scary. Even when it's vulnerable.

Be love.

Always be love.

Back in university, my roommates and I woke up one day to a stranger sleeping on our couch.

The morning light poured in through our living room window, and this young man was just lying there, dressed in a suit.

After confirming that he didn't "belong" to any of us, we decided to wake him up.

So there we were, four roommates, in our pajamas, gently trying to nudge a complete stranger back to life.

He slowly opened his eyes, sat up, and stared at us in confusion.

"Where's Jeremy?" he asked.

"No one named Jeremy lives here," we told him. "What are you doing here?"

He took a deep breath and looked around curiously.

"I honestly have no idea," he told us. "I was sure I had followed the directions properly . . . but obviously I went through the wrong door. I'm so sorry."

Evidently, this man had been told he could crash at his friend's house for the night. We, apparently, had forgotten to lock our front door. One wrong turn, and that friend's house turned into our house.

Whenever I think back to this story, the universe pauses for a moment.

Because the humanity of it all.

How many of us have woken up one day to find that we took a wrong turn in life?

How many of us have looked around only to find ourselves somewhere we never intended on going?

Maybe we thought we were following the right directions, or maybe we just found a door that happened to be open.

Either way, this moment . . . is everything.

Because sometimes we're all a little tired and we're all a little lost and we're all in need of a place to rest our heads.

I will always remember that morning. I will always remember the look on his face. And I will always remember the question that came next . . .

"What do I do now?" he wondered.

All of us just stood there in silence while he searched for an answer.

"I guess I should head out and try again." He quietly laughed. "Maybe this time I'll end up in the right place!!!"

With that, he stood up, straightened his tie, and walked right out of our house.

A bit disheveled. A bit embarrassed. A bit discouraged.

But off he went . . . into a new day.

And there you have it . . . quite possibly the answer to all of life's obstacles . . .

Stand up. Straighten up. Try again.

We came home the next afternoon to a case of beer on our doorstep and a note that said,

I'm sorry if I scared you.
Thank you for not calling the police.
ps—Jeremy says hi!

Moral of the story:

There's something to be said for taking a wrong turn every now and then.

And there are lessons to be learned from people who trespass in the middle of the night!!

A couple weeks ago, a friend and I had a conversation about the inner tension that can exist between the desire to be truly seen and the fear of being truly found. That struggle can be very real and, for whatever reason, it made me think back to the summer that I turned sixteen years old . . .

I was working at a camp that year, and a group of us joined together to play a giant game of hide-and-seek one afternoon.

People hid behind trees, amid fields, tucked themselves in tiny dark corners of sandy playgrounds. We were everywhere.

Hide-and-seek was never a game I especially liked as a kid, but I was good at it. And on this particular day, I was the best at it. After an hour went by, I was the only one left hiding. People searched everywhere until, eventually, they gave up, and I decided to let myself be seen.

Guess where I was the whole time?

About ten feet away, just sitting with a family that was having a picnic.

I literally hid from them in plain sight.

I think I was drawn back to this moment during our conversation because this is how life often unfolds when we keep our true selves from the people around us: we hide before their very eyes. We hide behind our humor, our intelligence, our jobs,

our exterior. All in the hopes of keeping our deepest fears and insecurities tucked away in a place where they can't be found.

Sound familiar at all?

Well, before you start getting really good at a game you're not even sure you want to be playing, let me tell you what I learned that afternoon . . .

If you hide well enough, eventually people just stop looking. Because always having to pull someone out of their dark corner gets pretty boring after a while. Sure, you may get commended for finding a brilliant hiding spot, and sure, you may even get the bragging rights to go along with it; but, at the end of the day, you're also the person who's been sitting all by yourself for a really long time.

And that's what hiding does: it leaves us alone. Tucked away in plain sight, leaving people wondering where—and who—we really are.

We do this, thinking that it's all part of the game. And yet we forget that the best part of playing hide-and-seek was being found. At least it was for me. Because that's where the excitement was. That's where the laughter was. That's where the togetherness was.

And so it goes with life . . .

If no one can truly see us, then it's easy to feel like we're winning . . . when, really, all we're doing is hiding.

All this to say: life's not a game.

Let yourself be found . . .

**My kids cried the other day when they awoke to find that
it had snowed again.**

They looked at the ground beneath them, and you could see the
frustration come across their faces.

We're experiencing a transition right now that can be a
challenging time for us in Ottawa; it's not really cold enough
anymore to truly enjoy winter. The ice has thawed too much
for us to skate, and there isn't enough snow for us to toboggan
anymore. But it's also not warm enough for us to fully embrace
spring either. The park is all muddy, and the flowers are a long
way from blooming. It's not really clear which season we're in.

So each morning, we go through the motions, waiting through
this strange sort of seasonal limbo.

We put on our coats and mitts and hats and boots, only to end
up too hot wearing them and too cold without them.

We show up for winter, without really having winter be there to
meet us on the other side.

And it can feel hard; longing for what you used to have, hoping
for what you could have, only to find yourself stuck somewhere
in between.

"I liked it better when we could be all in, Momma," my son
would say.

I get it.

I've realized over recent years that I feel the same way about relationships that my kids feel about this time of year; given the choice, I prefer to be all in.

We often talk about people coming into our lives for seasons—which they often do—but we seldom talk about the ones that rest somewhere in between the seasons. The ones that aren't what they used to be, but haven't made their way to become something new.

Those are the ones that still feel a long way from blooming.

This place in any relationship can be especially hard for me. Because it's messy and confusing, and I don't like the uncertainty of not knowing which season we're in.

I don't like showing up for a relationship that isn't there to meet me on the other side.

It feels frustrating and painful.

The reality is, though, that relationships change. They change because people change and lives change and circumstances change.

And sometimes, that's what this "in-between" place really is: simply a season of its own . . .

A season of change.

We sometimes forget that change—even in our relationships—doesn't have to be a bad thing.

Change often gives us the chance to plant seeds, to find roots, to become something new.

Sometimes the most beautiful things grow under the harshest conditions.

But we have to allow it to happen.

Whether it's our relationship with God, with another person, or just with ourselves.

Sometimes the only thing to do is show up, surrender to the "in-between," and simply say . . .

I'm all in.

When I was about ten years old, my friends and I used to write stories together. We would each write our own chapters—picking up where another had left off—and in the end, we made beautiful worlds from our collective imaginations.

We created adorable love and wild adventures. We created deep sadness and joyful tears. We created beautiful triumph and glorious victory. And sometimes, we created a circle of friends, just making their way through life.

And there was only ever one rule: whoever held the pen did the writing.

No one else.

But in all the times that we wrote together, I never wanted to start. I never wanted to create the character. I never wanted to write the first page.

I was only ever comfortable letting someone else outline the script so that I could carry on.

And I never thought anything of it until twenty-five years later, when I woke up one day realizing that I had lived most of my life the exact same way . . .

The sun had been streaming through our bedroom window that morning, and my pillow was nearly soaked through with tears. My husband looked through the doorway and slowly crawled into bed next to me. He put his hand on the side of my face and quietly whispered, "You need to stop doing this to yourself."

I had been deeply hurt by someone I cared about, and six months earlier I had been in this very same place, with this very same person, feeling this very same pain. And once again, my husband sat with me as my heart was shattered to pieces along with every last bit of my self-esteem.

For six months, I had stayed in a friendship that tore me to pieces because I believed that the only person who could free me from my pain was the person who had inflicted it upon me. I believed that the only way out of my feelings of rejection was through the validation of the person who rejected me.

I believed if I could do more, be more, and prove more, then I could change the person I had become within this story. Then I could finally stop being the person who was only worth hurting.

And this had been so much of my life—being chained to the role I played in other people's lives. Which meant that my sense of self-worth was tethered to whether or not someone else liked me, accepted me, and validated me.

You start the script, and I'll continue where you left off. Just tell me who I am, and I'll write you the next chapter.

It sounded painfully familiar.

While I sat there, under my blankets, with the tears pouring down my face, I discovered for the first time that I had been overlooking the single most important rule about writing our collective stories: whoever held the pen did the writing.

In the story of life . . . YOU HOLD THE PEN.

Always.

Regardless of how you feel. Regardless of what is happening. Regardless of what anyone else tries to tell you.

You get your story. I get mine.

Other people can impact our story, but no one else should be writing it.

Which means that your story is not being written by the person who cut you out of their life or the parent who could never be pleased. Your story is not being written by the one who broke your heart or the friend who treats you like you aren't quite enough.

Your job is not to wait for someone else to tell you what comes next. Your job is to keep writing.

Not someone else's story of you.

So write the story of a person who risked love all over again or the story of a person who stood tall alongside their imperfection.

Write the story of a person who picks up all of the pieces and puts them back together again, or the story of a person who followed the road less traveled.

Write the story of a person who possesses strength and compassion and love and resilience.

And most of all, write the story of a person who never stops holding the pen.

Ever.

I'll always remember what it felt like to sit there—so long ago—waiting for my friend to arrive. I'll remember the way my breath quickened, the way my heart raced, the way I played with the brand-new wedding ring on my finger. I'll always remember seeing her walk through the coffee shop door, and I'll remember the sadness that came over me almost immediately.

The two of us had been friends for a number of years, but something was happening; a subtle tension, an underlying conflict, an unspoken battle had started taking place. And I didn't know why. So here we were, one last time, desperately trying to reconnect with the parts of ourselves that had made us friends in the first place. Before the passive-aggressive comments got thrown into the mix. Before we decided to show up with our armor instead of our hearts. Before we let our insecurities do the talking for us.

I think we all have pieces of ourselves that feel more fragile than others, insecurities that have roots much deeper than we would like. Cobwebs of shame that haven't yet been dusted away. Sometimes we're aware of our vulnerability; other times it's a complete blind spot for us. Either way, though, we all have them. And we all react differently when they are sliced to pieces by someone else's sword.

I tend to pull away in those instances. I withdraw from the arena and let the battle die a slow death. But sometimes I don't. Sometimes I allow that quiet whisper inside of me to turn into a booming voice. Sometimes I permit that insecurity to rise to the surface and declare war on my opponent. Sometimes I hit back.

And that right there is the defining moment for me: not the moment when I stop liking the other person in a relationship, but the moment when I stop liking myself in a relationship.

That was the first time I had ever walked away from a person I loved. I looked across the table at her and immediately knew I had a choice to make: to be quiet or to be loud. So I took a deep breath, lowered my eyes to the table, and with a single tear rolling down my cheek, I said goodbye.

And that was the end.

It had taken me months up to that point to make sense of what was happening to our friendship. To emotionally accept the loss of a person that had once mattered so much. But as I stepped out the coffee shop that morning, feeling the sunlight hit my face, I began to understand it . . .

There are two kinds of dynamics that we can experience with people in this life: the ones that require you to BE somebody, and the ones that know you ARE somebody.

One dynamic competes with you, while the other encourages you.

One dynamic uses your pain, while the other sits with you while you endure the pain.

One relationship finds the cracks in your armor, while the other leaves all weapons at the door.

One relationship makes you prove yourself, while the other helps you love yourself.

One relationship screams through insecurity, while the other sits quietly in confidence.

It's been thirteen years now since I first realized this distinction, and I still catch myself in these hurtful relationships sometimes. And they are confusing to me because I know deep down that no one can thrive under these circumstances. Because everyone just keeps yelling until, eventually, we all lose our voice, and no one likes themselves very much.

But I am starting to learn one thing: if someone needs me to be something . . . I'm guessing that whatever it is will never be enough.

So please believe me when I say that I'm making this next statement just as much for myself as I am for anyone else out there who might need to hear it . . .

You already are someone.

I already am someone.

And that person on the other side of the table already is someone.

It can just be really easy to forget in the moment. Because the world can be loud and our insecurities can be even louder.

So let's just sit together, quietly, and remember that we are someone.

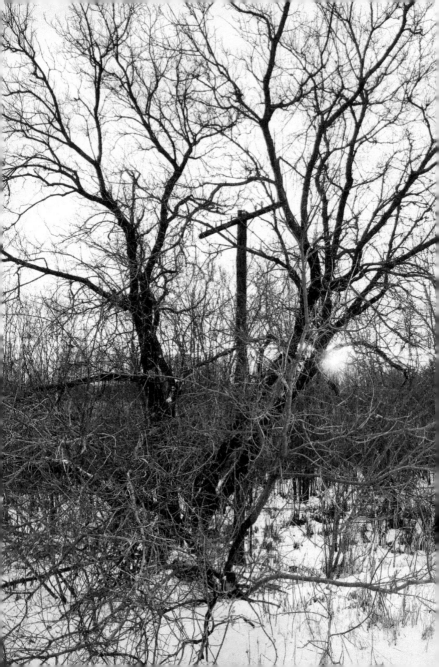

Our house faces a stretch of trail that runs for seventy-two kilometers from east to west. It passes through everything from pastures and wetlands to an eighteen-hole golf course. The trail used to be an old railway track and opened up as a nature trail about ten years ago.

We use this trail almost every day. We've taught our kids how to ride their bikes on this trail, I've done countless training runs on this trail, and we've watched shooting stars from this trail.

But it was nearly two years after moving here that I noticed the old railway posts staggered throughout the trees. Right there, standing alongside the birch trees, light bulbs still intact. And they are everywhere . . . this beautiful reminder of what this space used to be.

I'm often conflicted about my past. I often wonder if it needs to be tucked away neatly somewhere in order to make the best of my future. On the one hand, my past created the person I am today. On the other hand, that hasn't always been a person that I've wanted to be. I've often just wanted to change, to become someone different, to pour a bunch of gravel on the life I used to have and be turned into something new.

But then there are these light posts. These beacons. These reminders that the past and the present can peacefully coexist in one place.

If we let it.

If we stop trying to tear everything down . . . time will simply begin to grow around it.

If we stop trying to control what is and what was, eventually it all just . . . becomes.

A new scenery. A new truth. A new creation.

And sometimes it happens without you even knowing it. Sometimes, you'll just head out on the trail one day and notice that little pieces of your past have been there all along.

We can't change the fact that before this was a trail . . . it used to be a track.

And I can't change the fact that before I could find myself . . . I had to lose myself.

But I can go out my front door and walk amid the beauty that is both.

I was busy making dinner in the kitchen that night.
My son was two and a half, and my daughter was just shy of her
first birthday. For some reason, I remember looking out our
kitchen window and being surprised at how early the sun was
now setting. The seasons had changed, and I hadn't even noticed.

My husband was bustling around in his work attire, unloading
the dishwasher and talking about his day. And then it happened.
I accidentally knocked the full ketchup bottle off the counter,
and it fell to the floor. Shattered pieces of glass everywhere . . .
ketchup hitting every square inch of the kitchen . . . and all of us
just staring at the mess in complete silence. I looked down at the
floor, then back at everyone else, took a deep breath, and carried
on. I stepped over the puddles of ketchup and continued to make
dinner. As though nothing had happened. And in my attempt to
avoid the shattered chaos of it all, I stepped on a piece of glass
and cut my foot.

My husband looked at me in confusion, grabbed me by the
shoulders, and said, "Gen, stop! We have to deal with this first
. . . we have to clean up this mess."

And then I fell to the floor in an ocean of tears, and I didn't know
if I could get up.

I had been hurting for so long, and I just couldn't walk around
it anymore.

I think many of us are or have been that glass bottle, keeping it all together. We stand tall, we keep things contained, and from the outside, no one would ever know. And other times, we fall, and we become the shattered pieces amid a giant mess.

I've been both.

Anxiety was my mess, and anxiety blew me to pieces. But anxiety was also very easy to hide most of the time. So that's what I did.

The anxious mind is a powerful force.

Anxiety has taken me to very dark corners and caused me to react to situations that aren't real. Anxiety has cost me my memory and my relationships. Anxiety has stripped me of peace, joy, and the ability to be still through the night. Anxiety has held me hostage in ways I never thought possible.

And no one knew.

Until finally anxiety took me to my kitchen floor, surrounded by my suffering and fragments of the person I once was.

It was a devastating night for me, and one I'll never forget. But after all the tears had fallen and all the words had been spoken . . . I stopped trying to avoid the mess that night. And every day since. With family, with friends, with doctors, with neighbors. They each picked up a mop, and with their help, I was able to clean things up. But it wasn't easy. I had been standing in that disaster for a very long time, and it was EVERYWHERE.

And as a person who has had years stolen from her at the hands of this demon, as a person who knows how much it can make your muscles hurt, your mind drift, your soul ache . . . please trust me when I say that I get it.

When you are surrounded by life and demands and responsibilities and deadlines . . . it's easy to push your own needs aside. It's easy to say that everything else has to come first. It's easy to keep making dinner while everything has just fallen apart in your kitchen.

But, you guys, if you are reading this right now and you are suffering through your own mess, I need to tell you something: the danger isn't in falling to the ground; the danger is in trying to pretend that it didn't happen. Because now you are standing among a thousand shattered pieces, and, eventually, those pieces will hurt you.

So please don't step over it. Please don't ignore it. Please don't pretend that there isn't glass sitting at your feet.

Dinner can wait. Homework can wait. Everyone else can wait.

THIS cannot wait.

It can't wait because the world needs you and you deserve better than this.

Your health matters. Your happiness matters. Your peace matters.

Let the kids stay with the neighbors if you need to. Call a doctor if you need to. Take the day off if you need to.

But please stop.

And know that it's okay. There are plenty of mops to go around.

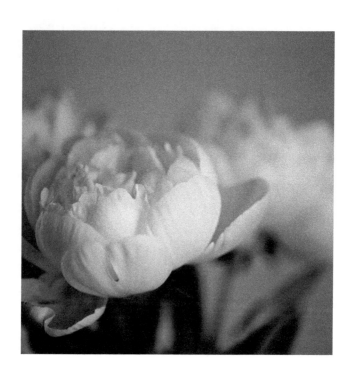

We tend to define it in more absolute terms. We tend to recognize it in more obvious places. We tend to acknowledge it in more worthy people.

And so we tend to forget.

We forget that we are brave.

We see it in the battles that have been fought, the challenges that have been overcome, the dreams that have been chased. We see in our news feeds, our headlines, our prime-time television.

And we forget.

We forget that bravery isn't only found in the bold leaps off the edge of a cliff.

In fact, much of the time, bravery is found in the tiny steps that are taken when no one else is watching.

It's in asking the hard questions and waiting patiently for the right answers. It's in taking care of small children and holding the hands of elderly parents. It's in accepting the truth about yourself and surrendering the truth about other people. It's in letting go, and it's in holding on. It's in trusting, and it's in believing. It's in mending a bruised marriage, and it's in navigating a wounded friendship. It's in choosing yourself. It's in grief, and it's in inspiration. It's in starting a new job, joining a new church, making a new friend. It's in nurturing your broken

heart and loving someone else through theirs. It's in saying "yes." It's in saying "no." Sometimes, it's in saying nothing at all. It's in the quiet whispers and the unseen tears. It's in the healing, and it's in the pain. It's in our vulnerability, and it's in our imperfections. It's in forgiveness, and it's in grace.

And sometimes, the bravest thing we can do is simply put one foot in front of the other.

When you look around the world in wonder at all the bravery that unfolds . . . don't forget to look in the mirror . . .

Because this, too, is courage . . .

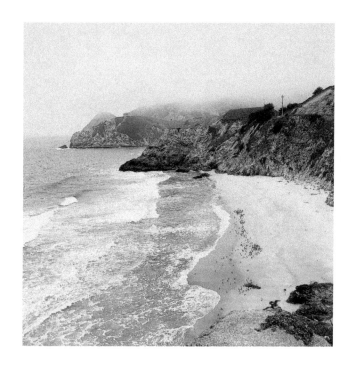

I used to sneak into churches when I was a little girl.

My family seldom ever went to church, and I was never really sure if I was allowed to be there.

So I would pull open the giant wooden doors, quietly peek inside, and if the space seemed empty, I would go sit in one of the immense wooden pews.

I was looking for God.

I was about seven years old the first time this happened, and I've been searching for Him ever since.

Sometimes I feel like I was born into this world with fear in my heart. As though I came into being with a certain unease that I could never quite explain. I've never trusted my ability to cope as a human in this life without shattering to pieces. And it makes me feel afraid. I feel so deeply and hurt so profoundly and love so immensely. And it has made for some really dark seasons in my life. Because it's not always easy for me to know if I'm being guided by my intuition or misled by my trauma.

I remember someone telling me one time that I was both the gifted and the cursed: gifted in the art of self-expression . . . but cursed with the experiences needed to create it.

To be completely honest, I haven't always known if one is worth the other.

But I have always known that I wanted to find God. And I wanted Him to find me.

I became Catholic when I was twenty-five years old. Every time I talk about it, I get asked why I chose Catholicism, and the only truthful response that I can give is that I didn't choose it. It chose me.

I can remember sitting in a bar one night and having some guy come sit down next to me. He politely asked if he could buy me a drink, and when we started talking, he pointed at the cross hanging around my neck, nodded his head, and said, "So, you're one of *those*?"

"Those what?" I asked.

"Those people," he replied.

I looked at him, partially confused and partially defensive. "I don't know who *those* people are, but I'm not one of anything . . . I'm just me."

And that's always been my most honest truth when it comes to God, because I've seldom fit very well into any kind of Christian box. Or any box at all for that matter.

I love Jesus, but I don't always love the church. I believe that any two people who love each other should be able to marry. I swear too much and have a few stories that I would rather leave behind. I constantly struggle with envy and patience. I fight with God a lot, and I'm terrible at surrender. I never really feel like I fit in at any church, and I'm always the person in a Bible study that asks a lot of super-annoying questions.

But I love God so much.

I've met people before with unwavering faith, and when they tell me about it, a part of me aches. Because I've never been one of those people. Because sometimes I still feel lost . . . unseen . . . reaching my hand out in the darkness, but no one is there.

I feel lost during this season of waiting and growth that seems never-ending.

And it has made me wonder at times if He's forgotten about me . . . or given up on me . . . or just doesn't want to find me.

Faith is not always an easy road to walk.

But then there's that little girl in me that keeps tugging at His pant leg, begging Him to notice me so He can wrap his arms around me and tell me that the monsters under my bed aren't real.

I'll admit that this wilderness I'm making my way through is hard. I know that it's meant to be a place of growth and healing, but the landscape feels so isolating. It has been sprinkled with moments of joy and relief and gratitude. But all in all, it feels as though I've been left alone to face my insecurities, and it pushes the edges of my faith, leaving me with a lingering loneliness because God just feels far away, and I feel abandoned.

My hope is that maybe God hasn't left me but rather is waiting for me. Maybe He's waiting for me somewhere in the long hours of the night or as day finally breaks free. Maybe we'll chat over coffee one morning or as I stare up at the heavens. Or maybe He's waiting for me where the water meets the shore.

I don't care where . . . I just know that I miss Him.

So, God, if you're reading this . . .

Please wait for me. I'm coming to find you.

When I was young, my biggest fear was that no one would ever fall in love with me. I was scared that I would never be the person that someone thought of when they woke up in the morning or when they went to bed at night. I was afraid of getting lost in the crowd or never being noticed.

About six months after my first love and I broke up, he called me at work one afternoon.

We sat quietly on the phone together, not saying a word.

"I'm afraid that you're going to fall in love with someone else," he finally said.

"I'm afraid that I'll never be able to love anyone else," I replied.

I sat behind my big wooden desk with tears slowly streaming down my face at the very sound of his voice.

Someone had fallen in love with me. Someone woke up thinking about me. Someone had reached out their hand in a crowd for me. Someone was hurting without me.

And it wasn't what I expected it to feel like. When I was young and thought about love, I never considered the part when your heart got shattered into a million pieces. I never considered the agony of having someone not love you back. I never considered the risk we take when we give a piece of ourselves away.

Even now, nearly fifteen years into the most beautiful love I've ever known, I realize that part of who I am was molded by who I lost. I think we all are in little ways.

I've literally been writing for days on end lately, which often means I have no idea which way is up or down! Putting words on paper brings out the restless nighthawk in me. When the lights are dim and the world is quiet. When the music is soft and my memories are whispered back to life.

Sometimes I forget how vulnerable it leaves me feeling. How exposed my soul ends up being. Like hearing the voice of your first love after your heart has forever been changed. While the act of writing is what ultimately heals me, it often destroys me first. Enduring that time in between can feel very raw, as though every wound I've ever survived has been ripped wide open again.

T. S. Eliot once wrote, "Only by acceptance of the past will you alter its meaning."[1]

And that's where I always go when I write: to the past. Because somewhere in there, an entire human being was shaped by love.

Having it. Losing it. Fearing it. Being it.

I've never known anything in this life with more potential to heal or destroy a person than the single connection two human beings can share.

Sometimes I wonder how we survive it all.

And yet we do.

So off I go . . . once more into the depths of writing, dear friends . . . once more . . .

There were days when I wondered if I would ever move past it. Days when I wondered if a moment would go by when I wouldn't stop to breathe through the pain. Days when I wondered if, eventually, the hurt wouldn't feel as though it had settled into my bones.

I knew as it was happening that this one was going to take a piece of me with it. I knew as my friend and I were in the last moments of our friendship that this one was going to take time . . . patience . . . grace.

I remember saying over and over again . . . "I don't think I can do this."

My heart had broken too much. And everything just hurt too much. And I felt it all too much.

The thing about painful circumstances is that we often think we can't do it.

We think we aren't strong enough. We think we aren't resilient enough. We think we aren't brave enough to find our way to the other side.

All the while, we forget that we already ARE doing it.

"I can't handle this pain."

"I can't get through this situation."

"I can't endure this struggle."

But you are.

The very act of being alive means you ARE doing it.

You are handling it. You are getting through it. You are enduring it.

It may hurt like hell, but you are doing it.

And someone needs to remind you of that. Because every breath you take, every moment you keep going, every ounce of yourself that is given to another day means that you are—in fact—doing it.

And you're here. Showing us exactly what strength and resilience and courage really look like.

So please . . . let me remind you . . .

You're doing it.

I am, too.

WE are doing it.

And it may not fully be the other side. But it's also not where we started.

Stand tall, my loves . . .

Because you're here. And you're doing it.

I've been thinking a lot lately about Peter and when Jesus asked him to walk on water . . .

"Come," he said.

Then Peter got down out of the boat, walked on the water, and came toward Jesus. But when he saw the wind, he was afraid and, beginning to sink, cried out, "Lord, save me!"

Immediately Jesus reached out his hand and caught him. "You of little faith," he said, "why did you doubt?"

It must have been so hard for Peter to step out of that boat, knowing full well that it went against all logic.

Faith says, "I'll get you there."

The world says, "People sink."

And being out there in the water can be so scary sometimes.

Right now, I'm pursuing a life that feels good on the inside instead of one that just looks good on the outside. And that means desiring less and being grateful for more. It means seeking progress instead of perfection. It means digging deep instead of staying too shallow.

"Come," he says.

Then I step out. And every time I do, it feels right. As though it's exactly what I'm supposed to be doing. Because God's gift is not about having or doing . . . it's about being.

Being a friend. Being a blessing. Being a light.

And I'm trying really hard to continuously step out. To keep my eyes straight ahead even though I don't know where that is.

Faith says, "I'll get you there."

The world says, "People sink."

I feel afraid right now, though.

I feel it every time someone asks me how many books I've sold.
I feel it every time the pains of comparison start to creep in.
I feel it when I wonder if I've already done the best I will ever do.

I feel the wind. I look away. And I fall.

But Peter fell, too. He got scared . . . he began to sink . . . and he cried out.

So today, my prayer is for the Peter in all of us.

For those of us who feel caught in a storm with desperately strong winds. For those of us who can't see the shore and don't know what lies ahead. For those of us who are trying to step forward while trying not to sink.

My prayer is for those of us who are crying out.

May our souls be calmed, may our fears be tamed, may our faith always be strong.

May we walk on water.

Life lessons from wildflowers:

Grow strong.
Stand tall.
Be wild.

I sat in my car and reached for my phone. Tears ran down my face while I searched for their name. With a racing heart and shaking hands, I typed out a quick text . . .

"I just wanted you to know that I'm thinking about you . . ."

And then I deleted it.

A few months earlier, we had gone through a painful falling out, and I was struggling to get past the hurt of it all. I would replay the scenario in my head and wonder what had gone wrong along the way.

But then there were other moments. Moments when I would feel everything that existed before we let our pain take us hostage. Moments when I would feel all the reasons I had cared about this person in the first place.

And in those moments, I kept wanting to reach out. I kept wanting to fill the gaping hole between us with something other than sadness.

But I was scared.

So I tucked the sentiment away in the deepest part of my heart, and it has stayed there ever since.

I read recently that there is a group of doctors who believe that suppression of love could potentially be the cause of most heart attacks. That is, we care about people . . . we make the conscious choice not to show it . . . and, as a result, our hearts literally break.

Take a minute and let that sink in, because if you're anything like me . . . it's not going to sit well.

Because it means that we don't just break because of the pain we keep bottled up inside, but we break because of all the love we keep bottled up inside too.

It means that every time I know I should apologize and I don't . . . I break.

It means that every time I delete a kind message because I'm scared . . . I break.

It means that every time I don't use the miraculous gift we've all been given to connect with another human being in a meaningful way . . . I break.

Something inside of me breaks.

And this is everything.

Because if you show me a handful of words that have been left unspoken, I'll show you a heart that's been aching to say them.

"I miss you."

"Please forgive me."

"I wish we could start again."

How many of us hold onto words that were never meant to be locked away? How many of us keep our hearts in a vault with the assumption that we're protecting it? How many of us are just scared of putting all of our love out into world for fear that it might never come back?

But the truth is, any time we allow a relationship to suffer because of fear, we inevitably end up suffering right alongside it.

I believe that there is a part of ourselves that wakes up every morning knowing that we innately belong to each other. And I believe that same part of us strives to contribute to this world free of expectations, personal agenda, and ulterior motives.

I believe that part of us simply knows that the human in me . . . loves the human in you.

I believe this was the part of me that typed out a message for a lost friend that was on my mind, before my courage got swept away by my fear, my pride, my pain. Before I got consumed by what someone else might think and how that might make me feel.

We often think that vulnerability leaves us weak and exposed. That it somehow shows the cracks in our armor. But what if vulnerability is what takes our broken hearts and makes them whole again?

What if it's not about the painful things we keep ourselves from saying, but all the beautiful things we should be saying? What if it's not really about hurting less, but simply about loving more?

I guess there's really only one way to find out . . .

Send the texts. Say the words. Surrender the fears.

And then watch.

Watch.

Watch what happens when the human in each of us . . . loves the human in all of us.

**My son fell off his bike one summer while learning to ride
without training wheels, leaving a huge scrape on his elbow.**
It's one of the bigger injuries that he's endured in his short eight
years, and the tears fell pretty hard. A couple of weeks after the
accident, he was getting ready for bed when I noticed that his
arm was bleeding again.

"What happened, buddy?" I asked him.

"Nothing, Momma . . . I was just picking at my cut, and now it
hurts again."

"Why did you do that, Hudson?"

"Because it's uncomfortable waiting for it to heal, and I wanted
the feeling to go away."

And there you have it: the story of my life for a really long time.

It was the story of a girl who had a few pretty good falls in her
day. It was the story of girl who picked at her wounds and made
them bleed all over again. It was the story of a girl who struggled
through the feelings and wanted them to go away.

Because healing is really uncomfortable sometimes.

It was so uncomfortable that, for a long time, I just didn't let myself get there. Maybe it was shame or guilt or unworthiness or fear; maybe it was just the itch that comes with growing new skin. But for most of my life, I chose to constantly rip open my pain instead of waiting for myself to heal.

Honestly, I think I was afraid of healing. I was afraid of who I would be without my pain. I was afraid of the person I would become once I was covered in scars. So it was easier to bleed. To be the wounded one. To sit through the hurt instead of embracing the healing.

Because at least I knew how to navigate the pain. I knew how to live in the world with a handful of broken pieces.

I think sometimes we become attached to our shattered selves. And for a period of time, it might even work for us. In some weird way, it might protect us and distract us and define us.

Being hurt by love gives us permission to be angry.

Being rejected in the past gives us permission to stop trying.

Being derailed on the road of life gives us permission to be lost.

But healing.

Healing brings forgiveness.

Healing gives us courage.

Healing paves the way.

But to do this, we need to let go of the pain and be willing to let something new grow in its place.

And those scars we might be left with?

They are the footprints of surrender. They are the love letters of time. They are the gateway of truth.

As I sat with my son in the bathroom that night, cleaning the blood that was dripping down his arm, I looked into his incredible, tear-filled eyes . . .

"Hudson, I know that it's hard, and I know that it's uncomfortable sometimes . . . but I really need you to be patient and give yourself the time to heal. I promise you, someday— hopefully very soon—you'll see why it's worth it."

Welcome to someday.

I'm walking in the early morning light of downtown Ottawa when I spot a dragon sleeping on the front lawn of our city hall. Her name is Long Ma, and she's thirty-six feet high, weighs forty-five tons, and has been snoring for most of the night. A few blocks away, perched atop our Notre-Dame Cathedral, is Kumo, a forty-ton spider that sprays water and requires over a dozen people to control all of her intricate movements.

These two mechanical beasts roam around, breathe fire, lie down, and, most of all, inspire wonder. They are visiting us for a long weekend from the city of Nantes, thanks to the French theatre company known as "La Machine." But this isn't just any visit. An awakening is about to happen. A mission is about to unfold. A battle is about to take place as these creatures live among us.

The story goes like this . . .

Once upon a time, Long Ma—half-horse and half-dragon—happily watched over humanity. Meanwhile, Kumo, the sinister spider, was determined to strip Long Ma of her magical wings. In the darkness of night, Kumo successfully stole Long Ma's wings and fled with them, leaving the dragon feeling powerless and bare. For many years, Kumo hid with the wings underground. But when she was forced to emerge, Long Ma began the quest to retrieve what was rightfully hers. Eventually, Long Ma's search brought her to our city, where we became the backdrop for an ethereal tale that would unfold before our eyes. Streets were wandered, confrontation was met, and battles were fought.

While it's certainly a story of pure magic and wonder, what's even more beautiful still is that it's all of our stories. Because, let's be honest, haven't we all felt—at one time or another—as though someone had stolen our wings?

Maybe they stole our hearts or our trust or our friendship. But haven't we all gone searching for that missing part of ourselves that someone else claimed as their own?

Haven't we fought tirelessly and wandered aimlessly and searched relentlessly?

Haven't we all faced some giant beasts in the name of feeling whole?

After much searching and many detours throughout our city streets, our dragon found her long-lost wings. Kumo fought hard, but Long Ma's determination prevailed. But our story didn't end there. The story never ends there. Because the story is never just about what we lost; it's also about what happens once our pieces have been found.

Do we seek revenge and battle to the death? Or do we take those wings and decide to soar?

I've been hurt before. I've been betrayed before. I've lost myself to another person before.

And it's hard not to hold that pain inside of you. It's hard not to breathe fire upon your opponent. But in doing so, I can't help but wonder, What do we really gain other than a pile of burnt wreckage? Does hurting someone else make you hurt any less? Does it determine who is right? Or simply who is left?

Because here's what I know to be true . . .

That person you're standing in front of is also fighting their own villain. But in this life, it's often easier to battle each other than it is to admit that the battle is with our selves.

It's easier to blame each other than it is to blame our insecurities, our fears, our self-doubt.

It's easier to fight in the name of justice than it is to take a step back in honor of grace.

This world is full of beasts that feel larger than life; it's just that most of them roam deep within us.

Finally, with Long Ma's wings intact, our two creatures find themselves ready to face off, like we so often do. Things get heated, rage is unleashed, and a story is brought to its ultimate finale.

But in this story, it didn't happen in a fiery defeat like we might have imagined. In this story, the end came in a quiet whisper.

With heads bowed and weapons lowered.

And stillness.

Because the real victory isn't in fighting to the death; the real victory is in realizing that the demon we're facing isn't each other.

In the end, we're all the dragon with stolen wings, and we're all the spider running away with our happiness.

But the only battle really worth having is for the freedom to simply spread our wings and fly.

per·dure

verb | *to remain in existence throughout*
a substantial amount of time

I stumbled upon this word one day by accident and immediately fell in love with it. It's derived from Middle English and is more commonly known as an ancestor of the verb "endure." I've always liked the word "endure," but I'd always felt as though it carried an undertone of effort, of struggle, as though great strength were required to make it through various circumstances. And there's something to be said for those moments that endure. But "perdure" gave me a feeling of ease, of certainty, as though it would remain unchanged despite the various circumstances. And this. THIS is what I fell in love with.

That constant.

That unbreakable.

That everlasting.

I got a message from an old friend a little while ago rather unexpectedly. I was looking out at the Charles River in Boston when my phone buzzed, and there it was. Just a few short lines, but so much to say. There had been a time when this person was a part of my day-to-day life. A reality. A truth. Until they just walked away one day and vanished into a memory. Now they were a bunch of letters on a screen.

Our friendship had endured once. With effort, with struggle, with strength.

I can remember looking at the message, seeing the subtle gentleness of it all, and suddenly feeling sad. Everything felt so long ago and so far away. And it made me think of this word: perdure. To remain in existence . . .

We do this to people sometimes, don't we? We hand them beautiful words and beautiful hopes and pray that it lasts. And then our hearts fill with pain when it doesn't. I've often had a difficult time accepting this, the idea that very few things in life are unbreakable . . . especially relationships.

For the longest time, I've had this turmoil existing inside of me. A turmoil that came rushing forth again when those letters appeared on my screen. A turmoil that doesn't really know how to come to grips with what it means to care about a person who has hurt me.

That's the thing about pain: it often forces us to push aside the love. Because it's easier to be angry than it is to feel abandoned, betrayed, and rejected. And so we often forget. We forget that the reason we feel the pain is because we care, because we miss, because there is actually something that is constant in all of this . . .

And that constant is us.

This season in my life is teaching me that I don't actually need someone's permission to care about them. I don't need their physical presence to care about them. I don't need them to hand me the everlasting part of life in order to care about them.

Even if they hurt me . . . I can still love them.

Even if they feel like strangers . . . I can still love them.

Even if they are merely letters on a screen . . . I can still love them.

It may not always feel easy. It may not always BE easy. But pain doesn't get to take that away from me. Time doesn't get to take that away from me. People don't get to take that away from me.

Perdure.

And as the wind blew through my hair and as the boats passed before my eyes, I finally smiled a bit. Not necessarily because I hurt any less. But because I decided to let myself love a little more.

I've been told that I am reckless with my heart . . . that I don't protect my greatest gift with enough armor.

And this may be true.

My heart has certainly endured some deep wounds over the years. From friends, from family, from the greatest of loves. But the reality of who I am is this: while I certainly love deeply . . . I don't do so easily. I have always been intensely cautious when it comes to relationships, and I've planted towering beams of steel around my truest feelings. So if I open the gate for you, then I will never really close it again. Because I believe that love—in all of its forms—is a miracle . . . and I believe the people that share in that miracle are worth holding space for in our lives.

This is hard for some people to understand. It's hard for me to understand. It's not always easy to reconcile my willingness to show up for someone after so many years . . . after so much history . . . after so much pain.

But I do it anyway.

And I think it's because in the midst of love . . . there is vulnerability. And in the midst of vulnerability . . . there is innocence. And in the midst of innocence . . . there is a whole other person.

And if we have experienced that miracle together, a part of me will always remember that part of you.

Innocent. Vulnerable. Loved.

It has been both my greatest strength and my most crippling weakness.

The words "reckless love" have come up at church a lot over the last couple of weeks. And hearing them takes my breath away a bit.

It makes me think about a night, decades ago, when I was losing someone I loved. We were standing in a park, the sun had just set, and the pain had settled deep inside of us.

"This hurts so much," he said, a look of despair coming across his face. "I need to know that this isn't the end. I need to know that I can hear your voice . . . see your face . . . be your friend. I need to know that you are *there*, even though you won't be *here* . . . with me."

I remember looking up at him with an ache that I thought would never go away and quietly replying, "I will be. Always."

And I meant it. Because I felt what he felt. He was just brave enough to say it.

I think it's why walking away for the last time is so hard.

Because we believe that when we give our hearts . . . we give a piece of our truest selves. We believe that while feelings may change, connection never truly dies. We believe in fighting dragons and shattering lies so we can remind each other of who we really are.

Because we are filled with reckless love.

I believe all of us are.

But when relationships shift, we often struggle with our desire to remain connected somehow to the people who have seen our most vulnerable sides. Even through time. Even through distance. Even through the immense pain we have sometimes inflicted upon each other.

We want to move forward, but we don't want to let go. We want to feel closure, but we don't want to forget. We want to hold hands, but we want to cover our hearts.

And it can be hard. Because relationships can be hard and love can be scary.

But I was reminded today that Jesus was also a man filled with reckless love.

He left the flock of ninety-nine sheep to be there for the one who was lost. He left them there—in the darkness of night—so He could lead one of them home.

He left them all. And He left them to find you. To find me.

It was reckless. It made no earthly sense. And yet it's what loving people does to us.

We want to drop everything we're doing. We want to rush to each other's side. We want to venture out into the night for a loved one who has wandered away.

It's reckless. It makes no earthly sense. And yet it's so beautifully human.

And part of me wonders what would happen if we let our reckless love loose upon the world? What would happen if all of us put aside our pride and our hurt and our fear so we could hold space for the people who have held our bare and beating hearts? Who would we be if we allowed ourselves to be truly seen and heard and felt?

I think we would be sheep . . . who would never have to be lost in the night.

I always sit through the final credits.

I always have.

When I really love a movie, I always sit there right until the very end.

I sit until the lights have come up. I sit until the last word has disappeared off the screen. I sit until everyone else is gone.

I sit there because I want to remember all of the details.

I want to remember how the story happened. I want to remember everything I felt. I want to remember the final song.

I sit there because I'm afraid of leaving too soon.

I'm afraid that something else might happen, that I might miss it, and that it could change everything.

So I wait until I know that it's all over. Until there's nothing left to see.

Even if that means I'm sitting all by myself.

I sit there because some stories are worth holding onto just a little bit longer.

Some people are, too.

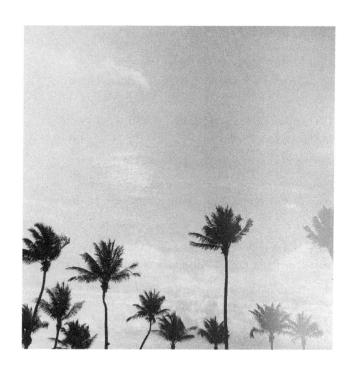

It was six months after I gave birth to my daughter.

The beach was empty. The air was warm. And I was terrified.

I showed up on this day because I had spent the majority of my life battling the exterior I was given. I didn't know how to love or appreciate or respect my body. I had never known how to look past my small chest or my untoned thighs or my broad shoulders.

I only ever saw inadequacy and imperfection and flaws.

My relationship with my body has been one of the most difficult and heartbreaking relationships of my life. It has been a struggle at best, a devastation at worst.

And somewhere in the midst of having my children and losing myself, I needed to find my way to neutral ground, to seek peace between who I was and who I thought I had to be.

So I sat on a beach, in a bathing suit, while a friend took out a camera and witnessed the first moments of me unchaining myself from a lifetime of pain.

And I cried for nearly the entire time.

That was seven years ago. And living cohesively with my body is something I have to work at every single day. And I will likely have to for the rest of my life.

I seldom—if ever—discuss this issue openly.

131

Because there is nothing easy about saying that you once starved yourself. Once tortured yourself. Once hated yourself.

And there is nothing easy about having another human tell you that you aren't entitled to feel that way because you can shop at certain stores or wear certain clothes.

I have learned, over time, that the only thing harder than being at war with yourself is watching others go to war over your right to be in that battle.

And so, most of the time, I choose to fight this alone. And I imagine I can't be the only one.

We live in a world that is bringing power to the notion of self-love and acceptance. We are seeing ourselves as more than the bodies we possess and the images we see and the standards we live among.

We are standing tall and rushing forth and being brave.

But I worry that we are also forgetting . . .

We are forgetting that EVERY body—regardless of the number stitched into the tag—can possess demons. We are forgetting that EVERY size is a "real" body to someone. We are forgetting that EVERY person holds on to a certain self-image. And that image isn't about what *you* see when you look at them . . . it's about what *they* see when they look at themselves.

"You have such long legs . . . you can't possibly understand."

"But you're so slender . . . there's no way you could know what it's like to be judged because of your body."

It breaks my heart every time I hear a statement like this being made, every time a hurting soul gets forced into isolation, every time a person is asked to walk alone because we've taken it upon ourselves to decide what they should or shouldn't feel.

We aren't breaking new ground if we compliment an individual's figure and then diminish their internal battle.

When you criticize someone's appearance, you are shaming their body.

When you criticize someone's feelings, you are shaming their mind.

Because a body type doesn't dictate someone's ability to know how it feels.

The five-year-old in me who was "advised" not to eat too much ice cream knows how it feels.

The ten-year-old in me who got stared at for standing three inches taller than all the boys knows how it feels.

The thirteen-year-old in me who got teased by other girls for having a flat chest knows how it feels.

The sixteen-year-old in me who was held down in the dirt by a guy twice my size knows how it feels.

The nineteen-year-old in me who watched her own beautiful mother struggle to feel accepted in the world knows how it feels.

The twenty-five-year-old in me who worked out fifteen times a week knows how it feels.

The thirty-nine-year-old in me who is trying desperately to be an example for her own children knows how it feels.

And while my experience may not be your experience, and while my battle may not be your battle, I know how it feels to be held hostage by shame.

I know.

We all do in some capacity.

Now, I do want to pause here a moment to acknowledge that not all of our struggles are created equal. While I may endure immense suffering at the hands of my own judgment and expectations, I also recognize that many women endure that same judgment and expectations from society as a whole. It's cruel and unfair and inflicts a degree of suffering that I—as a relatively slender woman of 5'8—seldom ever have to endure in the same way.

Please know that I see the injustice. Please know that I acknowledge the inequity. Please know that I feel the disconnect between each of our challenges.

I recognize that in a world where women's bodies are held to impossible standards, it can be incredibly hard to know who to fight against. And in the midst of that confusion, it's easy to simply wage war on each other. Because that's what we're set up to do . . .

Us against them.

And if we fight each other long enough and hard enough, then maybe we won't notice the real enemy in all of this, that it's not our legs or our smiles or our abs that are causing our pain. It's the voice. It's that tiny voice that whispers in our ear that our worthiness is found when perfection is reached. All the while, the more perfect we try to be, the more insecure we begin to feel. And the more insecure we begin to feel, the more walls we start to build.

Until we are all left suffering alone.

So it begs the question . . .

What's *really* worth building?

Safety or unity?

We can build walls between us because our bodies don't look the same way. Or we can build strength between us because we've all felt the same way.

One will hurt. One will heal.

And in a world that is constantly trying to tear us apart, I am left with one wish . . .

May we see ourselves more clearly, may we love each other more deeply, may we share our struggle more honestly.

And may we build together more wisely.

Confession: I'm not great with plants.

I try really hard, but I sometimes underestimate how much care they need, and I often lose the battle.

It's a loss that I never take lightly, though, and it's a loss that I had to endure again recently.

I had this beautiful little plant that sits next to me in my office, and I accidentally forgot to water it before we left for some holidays.

When we got home, it was all yellow and wilting.

It was struggling.

I tried for about a week to salvage its broken and wounded parts. But nothing worked.

So I finally succumbed one morning and cut off every single stem, leaving nothing but tiny roots poking through the surface.

And I took extra good care of it.

I moved it around to the sunniest parts of the house. I made sure it had all the water it needed. I held it in my hands at least once a day.

I poured all the love I could into this little guy and gently encouraged it to come back to me.

But it died.

Our three-week absence over the summer finally got the better of it, and I eventually had to take it off of life support. I was so disappointed.

I'll admit that it took me a while to let go. I had tried so hard to nurture it and care for it and repair the damage that had been done to it. I didn't like surrendering to the reality that I couldn't save it.

I often struggle through the same experience when it comes to relationships. I have a difficult time recognizing when there's nothing more I can do. So I hold on and keep trying. Pouring out all of my love in the hopes that I'm not left with a wilted version of something I once knew.

Last weekend, my husband and I were out, and I started looking for another plant to put in my office.

As we wandered around the aisles, I quickly caught myself gravitating toward the fake ones.

"Why are you looking at fake plants?" my husband wanted to know.

"I don't know. Wouldn't it just be easier?" I wondered, both to him and to myself.

And there you have it, folks; as I stood in a store full of greenery, with a heart full of feelings . . . I stumbled upon the most accidental of all truths . . .

When it comes to plants and people . . . fake is easy.

Fake is what can exist without needing an investment on our part.

Fake is what sits nicely in a room but doesn't give back to the space.

Fake is what gives us guarantees when real life has to go without.

Fake is what tricks us into feeling safe.

From loss. From rejection. From having to let go of one more thing that we tried so hard to save.

Fake is the easy way out because fake requires nothing real of us in return.

And fake is so easy to choose. I know because I've done it a hundred times before.

I ended up going with a real plant that day. I wasn't entirely confident about my decision, but I braved it nonetheless. It's a new kind of plant that I've never had before, and I'm slowly learning what it needs from one day to the next. I even start to panic a bit when it starts to look wilted or a leaf falls off. Because I'm not quite ready for another reminder that not all things can be brought back to life, no matter how hard we try.

But I guess that's the thing about life . . .

Plants die. People change. Relationships fall apart.

And it's hard.

But right there (sometimes in the middle of a plant aisle) is when we get to make some of our biggest choices. Will we choose the risk of real life over the safety of a glossy finish? Will we choose to give our hearts over guarding our feelings? Will we choose the vulnerable way through over the easy way out?

These aren't easy decisions. But in the end, when all is said and done, I think I'd rather lose something that was real than hold onto to something that is fake.

I knew a guy once that didn't have any mirrors in his house.

Not a single one.

We met back when I was in my early twenties through a group of mutual friends. We had matching souls at the time. Both struggling. Both cracked. Both trying desperately to close our hearts off from the world.

We spent a lot of time together that summer. Mostly in silence. Always in pain.

And we seldom smiled.

Because this wasn't a relationship about love or laughter or lust. It was about finding comfort in each other's presence, knowing that we didn't have to hurt alone.

We were only ever friends.

But we mattered to each other.

In the same way that the moon matters to the night.

We sat on rooftops and watched concerts. We sat in bars and drank beers. We sat along beaches and felt waves.

We became the raft that kept us both afloat, the last bit of air that remained in our lungs.

And then there were the mirrors. The nonexistent mirrors.

"I had some," he once told me . . . "but they're all broken now."

People are so full of mysteries. Secrets they keep hidden, even from themselves. Truths buried so deep that, sometimes, their gatekeepers forget they are even there.

My friend also didn't sleep much.

He had a single mattress on the floor of his room and Christmas lights hung from the tilted attic ceiling. Milk crates stood stacked in a corner filled with CDs, while heartbroken voices filled all of the spaces in between.

We would often just lie on that mattress, as the hours passed, waiting for daylight to set us free.

There was a darkness lurking inside my friend that kept him up at night.

That darkness was an accident that had happened many months earlier, before our paths even crossed or our eyes even met. A car accident that would cause him to witness his best friend's final breath. Among twisted wreckage, dripping blood, and broken glass . . . a haunting would commence.

"I couldn't save him," he once whispered to me, when his truth came pouring out—at four o'clock in the morning—under all those tiny Christmas lights.

"There was nothing I could do but watch him die."

We spoke more words in that one night than we had in all the previous months combined.

I gently held his hand as tears fell down my face and I watched him finally fall asleep. I slipped out a couple of hours later before he awoke, and we never saw each other again.

It wasn't really a painful separation. Instead, it just felt as though the purpose of our time together had been met, and now a flood of emotions was just washing us away.

My friend had endured some of the most unimaginable trauma. He lived through a moment that—God willing—most of us will never have to experience. But in our own way, so many of us are fighting to set something free. To unleash a beast that is holding us captive.

And my friend thought the mirrors were the key to his freedom. He thought if he could stop seeing that face looking back at him, the face of the person that he believed had failed that night, then he could turn his story into something different.

I always think of this when I struggle to face myself. Those mirrors. Because this is what our stories do to us: they reflect back to us the lives we live, the experiences we hold, the people we believe ourselves to be. Our stories become the image we project into the world. And sometimes, those things are really hard to see. So we run and we hide and we break all the mirrors. All so we don't have to look ourselves in the eyes.

My friend saw a man who let someone die. He saw a failure and a weakness and a brokenness that would never go away.

I saw a fighter and a survivor and a tormented soul that would never give up.

Same face. Same person. Two stories.

But that's the thing about life . . .

My stories aren't your stories, and your stories aren't my stories. But those stories pave the way for who we choose to become.

Every day, stories are being written for us. Every day, we're being given a hundred different pages to bring together. Every day, the chapters are unfolding.

And we can't always choose the stories that play out in our lives.

But we do get to choose who we become as a result of them.

Are we going to be the one who got rejected or the one who was brave enough to risk love in the first place? Are we going to be the one who failed or the one who at least tried? Are we going to be the one who isn't enough for some or the one who is more than enough for others?

I saw my friend two summers ago. I was sitting in my car at a red light, and he was standing at the corner waiting to cross the street. He had a little boy sitting on his shoulders and a radiant woman holding his hand.

As we waited for the light to turn green, he caught a glimpse of me and stood frozen for a moment. Eventually, I watched his shoulders relax, and he smiled. I smiled back. I don't know that we had ever seen each other smile before. And in that single moment, we said everything that needed to be said.

He was okay. We both were.

Somewhere in that time, we had faced our reflection, stared ourselves in the eyes, and made something meaningful out of what we saw.

He watched me drive off in the distance that day just like I had watched him fall asleep that night. I merged onto the highway and let a flood of emotion wash me away again. And this time it wasn't pain or despair or helplessness that I felt.

This time it was relief and hope and gratitude. Because for the first time, I truly understood . . .

It's never the mirror that's holding us back in life . . . it's what we see when we look at it.

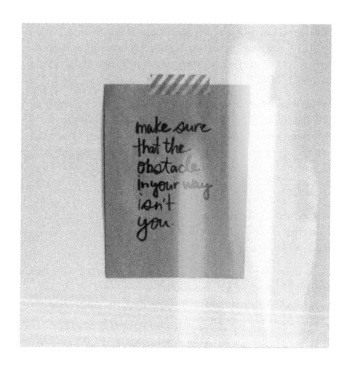

This is me, you guys. Me.

It's me when I'm trying to let go of someone. It's me when I'm trying to pursue what I love most. It's me when I'm trying to get better abs.

It's me.

And I think it's been me because, for all my ruthless tenacity, there are times when my fear tends to run deep. I'm afraid of what might happen if I walk away from the person who keeps hurting me. I'm afraid of what might happen if my dream falls apart. I'm afraid that better abs might mean less cheesecake.

But what all of that really means is that I'm afraid of change.

Because change is hard for me. It's unsettling, uncomfortable, and sometimes a bit painful. Even really good change can leave me feeling in unfamiliar territory. So I often resist it, even when I know deep down that it's the very thing I need to embrace the most.

But here's what I'm learning about change right now . . .

When I become consumed by everything that's changing around me, I forget that something is always changing within me.

And there's something oddly beautiful about this for me. Knowing that I am a part of ever-evolving sand that's being rustled up into the air and settling into its rightful place.

Change isn't something that is happening *to* me. Change is something that's happening *with* me.

I'll confess that this realization doesn't always make it easier. At least not yet. But it has forced me to raise a question or two when I'm in the throes of that restless discomfort . . .

Do we stop moving forward in the pursuit of our goals because we're afraid of the other side? Or do we become a bit braver, a bit stronger, a bit tougher as we allow ourselves to change along the way?

Yes, when we let go of fear and hesitation, things will change. Our time will change, our lives will change, and sometimes even our relationships will change. And that can be hard. But if we hold on to fear and hesitation, that will also create change—in our minds, our bodies, our spirits.

Which option—letting go or holding on—are we more willing to change *with*?

I'll be completely honest and tell you that this is still a tough one for me. I generally waver somewhere between the two options, depending on the day and how much coffee I've had.

But I will tell you this: if change is teaching me anything on this path I'm walking, it's that life will throw enough obstacles at us all on its own; we certainly don't need to become one of them!

I once heard that when dealing with others, you should always ask the following question:

> "One year from now, will you be happy with how you handled this person and their feelings?"

Of all the things to ask in the midst of a relationship, I thought this was the absolute best. Because sometimes emotions run high and hurts run deep and people run away. And in those moments, it's so easy to forget what we're holding in the palm of our hands: someone else's vulnerability.

And there was a time when this question would have been the only thing that mattered to me because other people's feelings were the only thing that mattered to me.

Until one day, I decided to ask myself another question:

> "One year from now, will you be happy with how you handled yourself and your own feelings?"

I think, for some of us, it can be really easy to get swept away caring for others. I've been known to lose pieces of myself in the name of someone else's feelings. Because I was afraid of how the situation would look if I didn't. In the battlefield of what mattered, I was afraid of crossing enemy lines, I was afraid of being wounded, I was afraid of not being fought for.

Mostly, I was afraid of finding out that I had been standing alone all along.

I can generally say that, as the years go by, I can look back and be happy with how I handled other people, but it's questionable whether or not I can say the same about how I handled myself.

Because somewhere along the way, I tend to forget that my feelings matter too.

Somewhere along the line, I end up taking a lot of bullets so no one else has to.

But here's what I'm learning . . .

I believe in relationships.

I believe they are worth fighting for, I believe they are worth holding onto, and I believe they are worth navigating our deepest fears.

Because people are worth it.

But I also believe that relationships are not a sword to throw yourself upon. Relationships should never ask you to be a martyr to the cause. Relationships are not a war to be won.

Because we are worth more than that.

I believe, a year from now, we should be able to answer yes to both of these questions.

So if you are battling to have your feelings be seen or heard or valued . . . I need you to know that it's okay to raise the white flag. It's okay to walk away.

Because it's not called giving up on someone else.

It's called fighting for yourself.

When I was young, I used to have an imaginary friend.
My imaginary friend had a quiet, gentle voice. And that voice
made living in this world a lot easier for me.

I often felt very alone as a little girl. As though I had somehow
been dropped somewhere that I wasn't meant to be. I would
watch everyone around me create friendships, make plans, make
space to belong. And I never felt like one of them.

I had beautiful people in my life, but something always felt
different. Every connection always felt somewhat at arm's length.

I was never someone's safety net. I was never someone's best
friend. I was never someone's first choice.

Even if they were mine.

And loneliness became a very real thing for me.

This early feeling of disconnect left me with an insecurity that
looks a little something like this . . .

*There is an almost constant underlying belief that I care more about
others than they do about me.*

I feel like the person who is easy to forget about. The person who
is easy to walk away from. The person who can lift out of other
people's lives without them even noticing.

And for a long time, it made something inside of me physically hurt. It brought a pain that never really went away.

But with age and with God, I learned to become a bit more at ease with my sense of separateness.

A knowing began to fill my soul that I was never really alone, and most of the time, that knowing was okay.

Until it wasn't okay.

Until the days when I would remember that I've never been in someone's wedding party. Or that I'm not the friend that someone calls when something exciting happens to them. Or that I'll never belong to a collection of inside jokes from a lifetime of growing up together.

It's in those times when those aching spaces would feel very deep and very hollow.

But it's also been in those times that I've come to realize that—for some of us—relationships can be a very polarizing experience.

We crave it and we fear it.

We are healed by it, and we are destroyed by it.

We need it and we resist it.

And somewhere in the middle, we find that innate desire to be tethered to solid ground.

But when I was a little girl, I didn't know how to sit through that discomfort. I didn't know how to understand my place in this world. I didn't know that—even in isolation—we could find strength together. So I created someone who did.

That someone had a quiet, gentle voice and was the embodiment of four words that made everything easier . . .

You are not alone.

I wanted space for those words to exist between people.

And as I got a bit older, I realized I had a decision to make: I could wait for someone else to bring me that space, or I could become the person to create that space.

So I began to write. First for me. Then for you.

I write because of the air that lingers between us. I write because of the truth that lives in that space where one of us ends and the other begins. I write because in our own unique way, we're all connected.

I write because I believe these are four of the most powerful words in the English language. Four words that blow over us and wrap us in the comfort of all our common threads. Four words that can reach down into the darkness and pull us all from the wreckage.

But in order for those words to exist, someone needs to blink first.

And so I write.

I write because I have come to believe that sometimes we all need a quiet, gentle voice to share the most beautiful of whispers . . .

You are not alone.

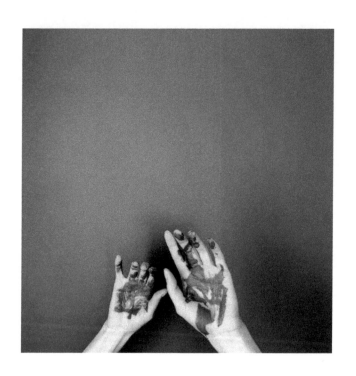

I wish I could tell you there was another way.

I wish I could give you a road map that was clean and flawless and perfect in every way.

But I can't. Because I've never experienced it.

I only know one way.

And it's messy.

Whether it's been creating relationships . . . creating art . . . or creating a moment.

It's been messy.

And I used to be afraid of the mess. Afraid of the flaws that might appear if things got dirty along the way.

Until I realized that the greatest beauty I've ever known has arisen from the disheveled pieces of a very messy life . . .

The most valued relationships I have in my life are with people who were willing to stand in the mud with me. Because there is so much beauty in walking through the trenches with someone, facing your battle, and finding your way out together.

The most precious art I've ever made in my life are the creations bound by grit and sand. Because there is so much beauty in having a vision, watching it dissolve to pieces, then transforming it into something new.

The most meaningful moments I've ever had in my life are the ones spent with my hands and knees covered in dirt. Because there is so much beauty in having been buried, digging yourself out, and uncovering the strongest version of yourself.

I wish I could tell you there was another way.

But I can't. Because I've never experienced it.

But I can tell you that life is often very messy.

And if you're willing to embrace that mess, there isn't just beauty on the other side of it; there is beauty inside of it too.

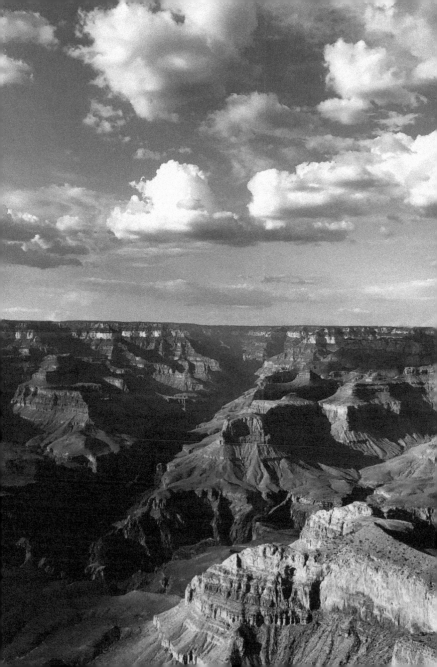

I got home that afternoon with a heavy feeling on my shoulders and in my chest.

"How did lunch go?" my husband asked.

"Oh, fine . . . " I replied.

"Are you sure? You don't look like it was fine."

A few hours earlier, I had been out with a friend. We sat in the crowded restaurant while the world seemed to flow effortlessly around us. We, however, did not. Where we once shared a close relationship, there was now a conversation that felt forced and a connection that felt weak. For some time, there had been a tension arising. A struggle. A quiet discomfort that filled the widening space between us. It was too subtle to pinpoint, but too obvious to ignore.

A couple of years earlier, we had experienced our first argument. Communication had been lost. Feelings had been hurt. Trust had been broken.

And we had just never talked about it.

Eventually, time passed, and it seemed as though the cracks had been repaired. But something was happening in our relationship, and we could both feel it.

That evening, my son was researching earthquakes for a project he was doing at school, and we learned about the way that the ground shifts beneath us.

It turns out that the various plates of the Earth are always displacing. It's a natural occurrence that we don't normally feel because, when that shifting goes unobstructed, the movement is smooth and the energetic release is subtle. It's when there is a block to that natural movement that a new force begins to have an impact.

Stress builds. Tension rises. Pressure mounts.

Until.

Until it all becomes too much. Until the energy finally breaks free. Sometimes in violent and destructive ways.

I read once that nearly all tension in a relationship is rooted in the first unresolved issue that was shared between those people. I had to sit with that statement for a while. I had to let it sink into my bones and settle into my being. Because, as I read this, I was also beginning to understand the value of having people in your life who are willing to struggle with you.

I wasn't raised in a home that knew how to manage conflict. When issues arose, we either erupted or we walked away. But we never sat down and allowed our most vulnerable selves to join us at the table. So I grew up believing that conflict was either a curse to be unleashed or a frailty to be outrun. But there was no recovering from it.

And I believed this for a long time.

But the reality of relationships is that they are a lot like the ground we walk upon; they are always moving and shifting. It's a natural occurrence for all of us to change over time, and when we allow space for that change, it tends to happen smoothly, without us really noticing. But if conflict happens and we don't address it, a block is put in place.

Stress builds. Tension rises. Pressure mounts.

Conflict, by its very nature, tends to get a bad rap. Somewhere along the way, we were taught that we're always supposed to get along and avoid the hard conversations that need to happen when we don't. But if the ground we stand on can teach us anything, it's this . . .

Not dealing with tension doesn't make it go away. It simply builds. Until something breaks.

And odds are, that very relationship you think you are protecting will suffer the most damage. Cracks will develop. Anger will erupt. Tidal waves will carry everything away.

Let's be clear . . .

There is a difference between avoiding conflict and dealing with it.

One tries to contain it. The other hopes to learn from it.

Some of the deepest pain that I've endured in my life is at the hands of people who need to avoid conflict. And in the name of wanting to be accepted, I've always taken it upon myself to navigate those relationships accordingly. As though it was my responsibility to meet others where they stand.

Until.

Until I started to notice that it all became too much. Until the energy started to break me. Sometimes in emotionally violent and destructive ways.

Because when we try to avoid conflict on the outside, it tends to build on the inside.

And one of the most important lessons I'm learning right now is that I can't change how other people respond to the discomfort of conflict. But I can accept them for who they are, while still honoring who I am.

But before I could begin that lesson, I had to figure out who I was.

I am a person who will go through the trenches with you. I am a person who will have the hard conversations with you. I am a person who will sit through the discomfort to find my way to the other side with you.

The most meaningful relationships I have in my life are the ones that have traveled through this place.

I am a person who believes that one of the most loving things we can do for another human being is give them space to be imperfect.

Because experience has taught me that we seldom ever set out to hurt one another. But we can intentionally heal each other.

But only if we allow room for the feelings to be released.

Of all the crossroads I've found myself at lately, this has—by far—been one of the hardest. Because it means letting go. It means being honest. It means facing the truth that some people will only stand with you if the ground is always stable beneath your feet. And that, in and of itself, is a lot of pressure.

So there comes a point in any relationship, with ourselves
and with the people around us, that begs a really important
question . . .

Do we risk breaking for the people that won't stand among the
cracks of an imperfect relationship . . . or do we shift alongside
those who will?

Back when I was in my early twenties, there was a running joke among my friends. Any time we would all go out, they would inevitably find me, listening to some stranger who was an hour into a story that most often started with "I have no idea why I'm telling you this . . ."

While my friends came home from our weekend escapes with phone numbers and dates, I came home with history and other people's ghosts.

"Let's go watch Gen collect some stories," they would say as we all piled into a cab and headed to our next destination.

I didn't mind. I liked people and I liked hearing their stories. And I liked knowing that I wasn't the only one in the room who felt haunted.

I read a quote by Mitch Albom the other day that said, "nothing haunts like the things we don't say,"[2] and something about it makes me feel uncomfortable. It makes me feel as though someone has sat down next to me in a bar and instead of saying something . . . they are just sitting there. Still. Waiting for me to unleash all the words I've held onto for so long.

And that's not something I do very easily.

I can brush through the cobwebs of who I am, and I can walk among the scary shadows of what I feel, but I seldom share my vulnerability about another person. Especially if they are standing in front of me.

So instead, I allow the ghosts to live inside of me. I allow the unfamiliar sounds to keep me up at night. I allow the darkness to linger in the corner of the room.

And I think I'm not alone in that fear. Because all of those people who poured out their demons to me—they all shared words that were meant for someone else. They all had someone—someone who could stop the floorboards from creaking if they had just spoken their truth.

Yet there we were, in a bar, during all hours of the night, sharing with a complete stranger the very things that could set us free.

I'm sorry.

I miss you.

You hurt me.

This is hard.

I was wrong.

I'm scared.

I was thinking of you.

I think many of us have some version of these words lurking within us on a daily basis, but we hold on tight to our vulnerabilities. Because, honestly, I think sometimes we're more afraid of being rejected than we are of being haunted. And so we keep it to ourselves and hope that the dark shadows eventually move on.

As a person full of untold truths and ghosts of her own, I know this tension all too well. But it does make me wonder . . .

What's really haunting us?

The things we don't say? Or the fear that comes with possibly saying them?

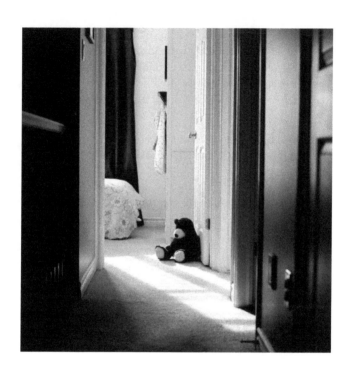

"Your dreams aren't big enough."

Those were the words.

Those were the words that came at me from across the couch and shattered my heart.

I was in another country at the time. In another time zone. In what felt like another universe. I had stepped outside the comfort zone of my quaint little neighborhood in suburban Ottawa and bought a last-minute ticket to attend a creativity conference forty-five hundred kilometers away. Upon landing, I somehow found myself sitting in a room full of people who were building orphanages in Africa and saving homeless women from inner-city streets. People who were creating clothing lines and human rights policies. People who were dream-chasers and game-changers.

People who were brilliant and driven. People who were changing the world.

And then there was me.

I was sitting in the midst of a very vulnerable time in my life. I had just had two children in less than two years, and motherhood was tugging at my deepest insecurities. While trying to be a good parent, wife, and friend . . . I was also just beginning to understand where the world left off and I finally began. On top of this, I was trying to build a photography business from my dining room table with a kit lens and a bare bones website.

I wasn't helping the needy. I wasn't rescuing the lost. I wasn't changing the world.

I was just trying to build something. To create something. To learn something.

Through my family. Through my work. Through art.

And that had always been enough for me.

Enough to light my soul with fire. Enough to fill my heart with inspiration. Enough to stir my spirit with purpose.

Then, here I was, sitting on a couch in the middle of a hotel courtyard. Completely surrounded by people again.

People ordering drinks from the bar. People sharing stories from their hometowns. People making plans.

And yet again, there was me.

I felt lost. I felt discouraged. I felt very much in the wrong place.

As an anxiety started to tighten in my chest, one of the organizers sat down next to me and gently asked, "So—how are you finding the conference so far?"

To be completely honest, I wasn't really sure how to respond.

"Ummm, well . . ." I cautiously responded, "I don't really feel like there's room for me here. My calling just feels so . . . different. My dreams just feel so much closer to home."

"The problem," she replied, "is that your dreams just aren't big enough. You don't want enough greatness for yourself. You should stop being so small."

And with that, she simply stood up and walked away.

I let her words wash over me, and then I slowly felt them enter through my pores.

I hardly said a word for the remainder of the conference, and two days later, I went home. Devastated.

And I stayed devastated for nearly a year. Broken. Confused. Shattered by the impact of her words.

In her defense, it wasn't her job to become my defining moment moving forward. It wasn't her job to set my course or to move my mountains. It wasn't her job to make me or break me.

But the thing about our inner voice—especially in seasons of great vulnerability . . . in seasons of great transition—is that it tends to ask a very specific question in response to uncertainty . . .

"What if they're right?"

And that's what happened to me in that moment and for the year that followed.

All I could ask was, "What if my dreams AREN'T big enough? What if I DON'T want enough greatness for myself? What if I AM being small?

"What if she's right?"

And I let these doubts and these fears battle it out inside of me like demons wrestling in the night. They scratched and they clawed and they ripped me to pieces until one day I learned the most valuable thing I've ever learned about the road to self-acceptance . . .

Ask your own important questions.

And that's where it happened. That's where the beauty began to rise. Not in someone else's questions. But in my own.

What if those dreams of mine ARE my greatness?

What if the small things are the big things?

What if my pursuit of raising strong children and being a great wife and documenting tiny moments CAN change the world? By the simple fact that doing so changes me?

And does that make my dreams any smaller than someone else's? Does it make my greatness any less?

The truth is that the world benefits from our happiness.
It benefits from our wholeness. It benefits from us digging deep
to become the best version of ourselves.

For some, that may be in the monumental acts that the world
defines as significant. For others, though, it may be in the tiny
details that many may never consider big enough.

But what I learned sitting on that couch so many years ago and
throughout the many days that followed is this . . .

A life filled with runny noses and carpools and supportive phone
calls to friends and piles of dishes . . .

THAT, TOO, IS HOLY GROUND.

That path you're walking—regardless of how insignificant it
may seem—is sacred. Because it's yours. And your life and your
actions and your steps forward touch everyone else's.

Our greatness isn't in the size of what we do. Our greatness is
in HOW we do it. It's in how we treat others when we do it. It's in
how we see ourselves when we are doing it.

It's in the breaths we take and the grace we give and the love
we create.

My dreams are big enough. And your dreams are big enough.

Not because a stranger says they are. Not because the world says they are.

But because YOU say they are.

And that, my friends, is pure greatness.

When I was young, I was attracted to one kind of man and one kind of man only.

He was always very tall, with dark eyes and an even darker past. I was drawn to the mystery . . . the darkness . . . the pull of only ever having a small piece of someone. I became part of their brokenness and fell through the cracks created by their wounds. Give me your hand, and I would give you my world.

And this was how I knew to feel loved: by rescuing. By following. By sacrificing all that I was for all that you wanted to be.

These relationships were all-encompassing, they were intense, and they always destroyed me.

But one day I met someone when I least expected it. Someone who didn't need me to fix him or save him or heal him. Someone who was just as surprised to have met me as I was to have met him.

Our early months of dating were not without their obstacles. It took us a while to commit to each other. It took us even longer to find a path we were willing to walk together. But fifteen years later, I'm married to the very person that enabled me to save myself. I've often wondered how it all happened because, given the chance, I know I would have spent the rest of my life seeking out people with deeper wounds than my own so that I could have felt worthy in all the wrong ways.

God knew that I needed THIS man.

I've often struggled to understand relationships. The agony and the ecstasy. The risk and the reward.

But I do know that relationships—the good and the bad—have the most to teach us. About ourselves. About our vulnerabilities. About the person we are ultimately meant to be.

And I know that God is in them.

My marriage is one of the best stories of my life. But the stories written before that were some of the hardest I've ever endured.

That family member that you are struggling to get along with. That friendship that is dissolving before your eyes. That love that is shattering to a million pieces.

It means something.

God is in there.

Reaching for you. Calling for you. Waiting for you.

And one day, when all is said and done, you will look up during the simplest moments of your life, and you'll realize that what you've learned is worth so much more than what you've lost.

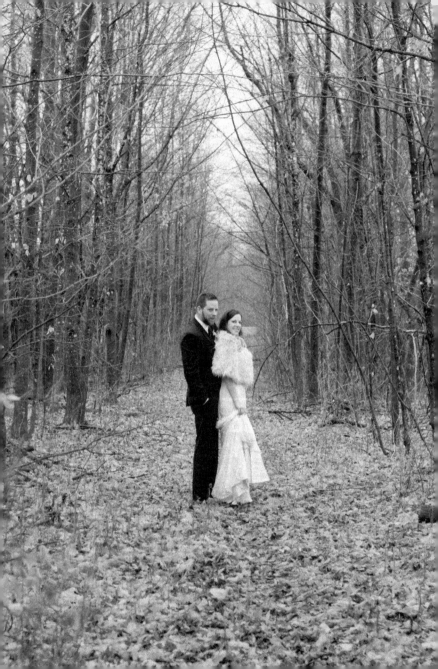

I've never fallen in love during the winter months.

I've been in love during the winter . . . but I've never actually FALLEN in love during the winter.

Apparently, when it comes to my heart, I'm a summer girl. Which surprises me a bit because I always feel more comfortable once the snow hits the ground. I like the vulnerability of winter. I feel like the world is a bit rawer and a bit more true. As it turns out, my two great loves both struck me in May, a time of year in which I naturally stand guard. While most people pursue summer with reckless abandon, I tend to feel unsafe and cautious as things warm up. If I'm being completely honest, I think that I just don't like myself as much in the summer. My soul just seems to relate better when the world has something to hide beneath.

I took an image of our two friends on the morning of their unusually mild winter wedding a few years ago. There were seven of us that morning, gathered in an old church out in the country. And to this day, it's still one of my favorite love stories. I don't know that I've ever seen two people more in love. Not just with each other . . . but also with the road they walked to get there. The beautiful grace that brought them together and led them to this place. This day felt ethereal. As though the laws of nature didn't apply in the face of such beauty. We saw the temperatures of late spring . . . the great love of deep summer . . . the stunning view of transitioning autumn . . . during the uncertain depths of midwinter.

It used to bother me that I never fell in love during the winter. I felt unsettled knowing that my heart had always been captured during a time when I loved myself the least.

But I'm starting to become okay with it now.

Because what I really saw that day was the delicate poetry of what love really is . . .

Too perfect for this world . . . too powerful for our demons . . . too divine for the fleeting seasons of my restless soul . . .

I can remember the very first time I saw her eyes.
One look, and I was completely in love.

Half Mommy. Half Daddy. All Avery.

But we started to notice it early on, in the first months of her life: that those giant brown eyes were playing tricks on her. We noticed it in the way she would look at certain things and in the way she would consistently bump into other ones.

It turns out that our daughter was born with a condition causing her exterior eye muscles to be abnormally tight. This meant that the otherwise effortless act of looking straight ahead actually caused her strain and fatigue. It also meant that it affected her depth perception—making her especially vulnerable to falls and missteps.

She fell nearly every single day.

She constantly ran into the corners of tables and counters.

She fractured her arm twice in six months.

Her little body was literally bruised and broken.

After eighteen months of seeing a specialist, we opted to have our daughter undergo a surgery that had the potential to completely and permanently correct this condition.

On the one hand, we were so blessed by the opportunity to have this option. On the other hand, someone hand me a bucket, because Momma's gonna throw up!

It was her eyes. Our beautiful girl's eyes, which we were told needed to be very carefully handled in order to perform the delicate work on the surrounding tissue and muscle. And that moment of watching our daughter be wheeled away into an operating room was one of the hardest things that my husband and I ever had to do as parents.

Furthermore, I felt apprehensive about sharing too much of our daughter's story. I was scared of needing support. Because I knew that there would be a parent out there, reading this, who was going through something so much worse. I knew that there would be a bleeding heart that had to watch their child go through a terminal illness or recover from a horrible car accident or (insert your worst nightmare here) . . .

I knew this wasn't the worst thing we could be going through.

I knew this wasn't the worst thing our daughter could be going through.

Therefore, I didn't know if our situation was "enough" for me to reach out. Enough for my feelings to be valid. Enough for me to ask for help.

But, for better or for worse, it was still very real for us.

The anxiety was real. The fear was real. The uncertainty was real.

And the act of trying to decide whether or not our struggle is worthy of support? That was entirely a human thing. Not a God thing.

Because God thinks all of our challenges are worthy of having our hands held through our darkest hour of waiting.

And I believe that's why God gave us community. Because that's what life in community is: it's about using our breadth of experience to walk a painful road together, not to diminish the ground beneath our feet.

Yes, perspective is important, and perspective can help keep us tethered to the gratitude when life starts to carry us away. But our pain and our fear aren't meant to be held on a spectrum of comparison. They're meant to be held in our hands and, hopefully, shared with others, so we can carry them together.

Be it broken hearts, financial difficulties, health issues, spiritual battles, or just a bad day . . . what's real for any of us right now matters.

It was through this painful experience that I actually learned the most about community, because it was in this very real moment when I needed other people the most.

While God often felt far away, others drew near.

The morning after the surgery, I could hear our daughter's little feet slowly and cautiously shuffling along the carpet into our bedroom.

"Mommy, it hurts. My eyes hurt," she cried out, tears streaming down her face.

Her eyes were swollen and completely bloodshot. Tiny silk stitches could be seen where incisions had had to be made.

It wasn't easy to look at.

And my heart sank as I watched her wince in pain each time she blinked.

The surgeon had told us that the procedure was a complete success and that he anticipated she would have a flawless recovery.

There are no words to describe the relief that we felt in that moment. Relief for our daughter, but also relief for ourselves.

The thing about our daughter's condition was that it was all she really knew. She was born with those eyes, and she had no idea that the world could look or feel any different.

So the decision to operate was left to my husband and me. And it was one of the hardest decisions we've ever had to make. Because our daughter didn't *need* this surgery. Our daughter could have continued on, happily going through her days, finding joy even amid the struggle.

Her life didn't depend on this. But the quality of her life did.

We knew that allowing someone to cut the tissue around her eyes would hurt. We knew that the discomfort would get worse before it got better. We knew it would be an experience that would stay with her forever.

And we also knew that there was something so much better for her on the other side of it.

Victory would come from her season of pain, but first, our little girl was literally going to have to cry blood-soaked tears.

And if community has taught me anything, it's that many of us quietly shuffle along in our own deep suffering.

We fall.

We get bruised.

We break.

And it's hard.

But it also makes me wonder if God looked upon us and had to make a decision . . .

"I know that your life doesn't depend on the pain you're about to walk through, but I know that the quality of it does."

I wonder if God looked upon us knowing that we could continue on, going through our days, finding joy amid a struggle that we've always lived, all the while knowing that there is something so much better on the other side?

But it could mean going through a season that hurts; it could mean the discomfort gets worse before it gets better; it could mean an experience that stays with us forever.

But in community, our hearts are able to ache alongside each other's.

Together, we can cling to the healing and the clarity and the ability to look back and know that our pain is filled with purpose.

And when seasons of darkness fall upon us, we don't always have the strength to believe encouragement, let alone speak it. Because some days the weight is too heavy and the pain is too deep and our God feels too distant.

But the beauty of community is that we don't always have to. Because God works *through* people, especially in pain.

That's why we walk this life together: so we don't have to sit in the trenches alone.

We stand in community so that we can lock arms. So that when one of our own feels like the discomfort is too great, the redemption is too far, the wounds are too raw . . . we can rise on behalf of those who are being brought to their knees.

When one of our own is crying out to God through blood-soaked tears, we can remind each other that healing always happens.

One way or another.

It's often hard. It's often messy. It's often painful.

But it happens.

And when it does, you get to see the world with whole new eyes.

I once knew this woman who lived next door to us.

She was the same age as I was, and we both had little boys around the same age. We lived in a townhouse at the time, and our families shared a wall.

The two of us became friends as our children started to get older, and one night, when the boys were about four years old, we went out for coffee. Like all parents, we got talking about our little ones, and within a matter of minutes, my friend was in tears. With coffee in hand and the dim cafe lighting casting shadows across her grief, my friend fell apart before my eyes.

She began to tell me about the year and a half that followed the birth of her son. She was suffering from postpartum depression and anxiety and didn't want to tell anyone. She would cry every single day and would never leave the house with her credit card for fear that she would just get on a plane and never come home. She didn't have family around to help her, and she had fallen into a hole so deep she didn't think she could ever have children again.

By this point, my tears began to fall as well.

My friend was brilliant and talented. She had a very successful career and a great marriage. She had friends and a deep love for her children.

And she spent almost a year and a half curled up in the corner of her bedroom crying because she didn't know what else to do. She had kept this struggle to herself because she was afraid: afraid of what people would think, would say, would do.

The most heartbreaking part of this story for me was the fact that her bedroom corner backed onto my own bedroom corner. My beautiful friend spent a year and a half suffering, and she was right there—on the other side of that wall.

Any time I discuss the challenges of parenting in any capacity, things tend to get a little bit tense. The topic tends to hit a nerve, and words get thrown around. Sometimes I get called a bad parent. Sometimes I get told I have no right to struggle because I get to be at home with my kids. Other times, I just outright get told that I'm doing it wrong.

And this very reaction at the mention of parenting being hard speaks to an issue that has bothered me for years . . .

When we take a mother's experience (correction: a human's experience) and tell them that it's wrong or unjustified, we are putting that person behind a wall to suffer alone.

And this is not okay.

I'm actually quite curious . . .

When did motherhood become a competition to be judged?

Because, honestly, I can think of no other cause in this life that deserves more unity.

Be it stay-at-home moms or working moms. Be it single moms or married moms. Be it new moms or grandmothers. Be it the mom of six rambunctious soccer players or the mom of a single special needs child.

Our struggles are all different. Our strengths are all different. Our experiences are all different.

But they are all real and valid and meaningful.

And if we are concerned about raising children, then let me assure you that we aren't going to raise them by being right. We're going to raise them by taking down the wall.

Perhaps here's where part of our dilemma lies . . .

There is a fundamental difference between who our children are and who *we* are.

When someone tells me that I will miss the days of toddlerhood, they are often talking about my children.

When I tell someone that I'm struggling and that I'm hurting and that I'm afraid, I'm talking about myself.

And sometimes I think that when we discuss these issues . . . we aren't always talking about the same thing.

I'm sure there will come a time when I will miss their tiny onesies and watching them fall asleep at night, but please believe me when I say that I will never miss the person that I was when I was going through those moments.

And it's taken me years to find my footing inside this truth.

We are allowed to look at mothers and love mothers and support mothers as separate entities from their children.

We are allowed to join hands with mothers and listen to mothers and become a united front with mothers as an army of strength, instead of a jury to be faced.

It is my strongest belief that the best way to raise these beautiful little humans . . . is by raising each other.

Here's to loving each other!

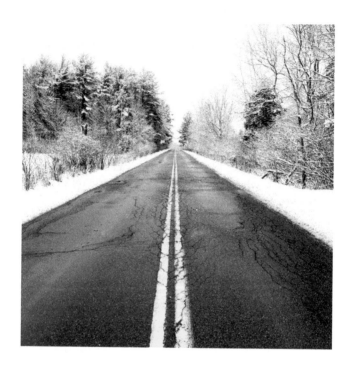

In 2010, I left my full-time job to become a photographer.
My son had just been born, I had never run a business before,
and I was teaching myself how to use a camera for the very
first time. Those early months had me up all hours of the night:
making a website, choosing a business name, learning about
exposure, reading photography books, and discovering the art of
truly building something from the ground up. I worked harder
during those first two years than I ever had before, and I loved
every minute of it. But there came a time—just six years later—
when I would cry anytime I got ready to go take photos. The
very thing that had brought me to life so many years earlier had
become the very thing that was depleting my spirit.

Our industry was starting to feel so relentless and competitive,
and my work was starting to feel invisible and irrelevant. I was
afraid that there was no longer a place for me doing the craft
that I once loved.

Art—in many ways—is like any other relationship. It's about
time and commitment, communication and expression, trust
and faithfulness. And also, as with any other relationship, falling
in love with your art is a beautiful thing, while falling out of love
with it is a heartbreaking experience.

Honestly, though, I didn't fall out of love with photography. Instead, I felt as if it had broken up with me. I felt as if it had found someone better to do life with, leaving me all alone, remembering all of the good times we once had together.

This was a dark and confusing season for me. A season filled with turmoil and sadness.

During this time, I had a conversation with one of my closest friends, who was in the midst of trying to reconcile a broken marriage. I can remember him saying to me, "If we ever get through this, it won't be about fixing our old marriage, it will be about the two of us building a new one."

The reality is that we change.

We change as people. We change as creatives. We change as business owners.

Sometimes we change together. Sometimes we don't.

And part of this past year has been about finding my way back to a love that had drifted away.

I guess you could say that photography and I spent a lot of time "dating" this year. Getting to know each other again. Remembering all of the reasons why we fell for each other in the first place.

And then building a new relationship together.

It was about booking fewer clients and creating deeper relationships.

It was about not just seeking the light but also finding the beauty in the dark.

It was about reconnecting with each other and also with myself.

And it's been a beautiful experience.

Of learning. Of humility. Of grace.

It's been a year of uncomfortably leaning into the reality that I don't want to "hustle" for my art.

I want to connect. I want to serve. I want to create.

I want to tell inspiring stories. I want to meet amazing people. I want to document a beautiful world.

I want to build something that I can be proud of.

Even if that means not being the trendsetter or the most sought-after.

Because, I've concluded, being in love matters more than being in demand.

You guys, if you are finding yourself wavering through something you once loved—a craft, a relationship, a life—can I encourage you to take a few steps back and return to the beginning?

Let yourself go to where it all started. Let yourself remember what it was like in the beginning. Let yourself change and be changed.

And then let yourself fall in love all over again.

It tends to hit me most right around the first major snowfall of the year, which—for those of us in Eastern Canada—tends to be around mid- to late November. As the ground becomes covered in a whole new season, something starts to fill my body that I instinctively know will stay with me until the year is done. It comes in the form of a free-floating anxiety. An overall sense of dis-ease that lingers in the background of everyday life, not quite noticeable on the outside, but entirely disruptive on the inside.

Christmas comes with a lot of mixed emotions for me. On the one hand, I love the anticipation of the holidays. Especially having young children, the magic of it all is nearly intoxicating. On the other hand, though, there tends to be a deep tension inside of me over the challenges that can come with an entire season built on the premise of joy.

To be completely honest, it just feels like a lot of pressure sometimes.

So I want to offer a word today about expectations . . .

As we make our way up to Christmas, I can honestly say that, if this year has taught me anything, it's that expectations can become the very death of the joy we're pursuing.

I say this as a person who has been tackling head lice this year instead of sending out Christmas cards, who's been recovering from the stomach flu instead of recovering from holiday parties, who's been searching for a single moment's rest instead of shopping for the perfect gift.

I say this as a person who had to stare her expectations in the face and find joy among the shadows of what I thought it would all look like.

It's been making me think about one of my most favorite movies: The 1994 adaptation of Louisa May Alcott's *Little Women*. It's the story of Jo, Beth, Meg, and Amy—four sisters going from childhood into adulthood after the recent loss of their family fortune. There's a scene early on in the movie when the girls come downstairs on Christmas morning to find their mother has been tending to a poor family down the street. The mother asks her daughters if they would be willing to give up their morning feast to the family as a Christmas gift and have their usual breakfast instead. The girls struggle at first but happily surrender the glorious meal before them, knowing that someone else needs it more.

My favorite scene, though, is when the meal is being packed up and one of the daughters notices the beautiful oranges sitting on the table. She picks one up with a slight look of mourning on her face, looks over all the details of it carefully, and, with a quiet breath, says goodbye to it before placing it in the basket.

I'm not going to lie: this holiday season was not what I had hoped for. It was filled with challenges and exhaustion and a depletion of my soul that I wasn't expecting. I felt like a failure a lot of the time for not being able to bring those expectations to life despite what was happening around us.

But right in the middle of that struggle, I learned something vitally important . . .

Sometimes, we all need to say goodbye to our oranges.

Because expectations keep us chained to the idea that our joy can only be found in one particular place: in the sequined dresses and the holiday concerts and the color-coordinated wrapping.

But sometimes, the simple nature of life means we will have to find our joy in other, more unexpected places: in the excessively long drives home to see family and the colds that everyone woke up with and power outages that took all of the Christmas lights with them.

It's not always easy. It's not always pleasant. And sometimes, it just downright hurts.

But I do believe that letting go is the only way to let something new in.

And in the midst of it all, we will celebrate a miracle.

A miracle that means so much more than any of the expectations I had placed before it.

My sweet friends, as I do my best to put my own oranges aside this year, I have a wish for you this holiday season and any season that may follow . . .

I wish you peace. Peace as you travel, peace as you share the table with others, peace in the deepest parts of your soul.

I wish you love. May you be showered with words that fill your heart, and may you offer those words to someone else.

And I wish you joy. May you find it in the unexpected places, in the shadows of your expectations, in the miracle that is to come.

Do you guys remember the story of the Israelites?

Moses led them out of Egypt and headed toward the Promised Land. A place of freedom and peace. But to get there, they had to cross the desert, which can be a pretty lonely and barren landscape. And the wilderness can be hard sometimes. It's not always easy to keep your eyes on where you're going or remember how far you've come. So we get distracted and discouraged and begin to lose our way.

This is what happened to the Israelites. Doubt and fear became their compass, and what should have been an eleven-day journey ended up taking them forty years. Many of them even died along the way.

Sadly, many of us never do find our way out of the desert.

Because no one tells you that the hard part of life isn't actually the wide-open spaces of doing the work. The hard part is being left alone with a bunch of inadequate feelings while you're there.

It's feeling lost when everyone else seems to know the way.
It's feeling mediocre when everyone else seems to be thriving.
It's feeling doubt when everyone else seems to believe.

For me, the hard part is continuing toward a place of authenticity when every insecurity I have is telling me to go in another direction.

Toward approval. Toward acceptance. Toward anything that makes the fear go away.

I wonder if Moses ever sat down with the Israelites and told them what had to happen before they could reach the Promised Land. Did he tell them how hard it would be to not compare themselves to others every moment of the day? Were they warned about how easily feelings of shame would bring them to their knees? Did anyone explain to them that the more they tried to keep up . . . the more their self-esteem would deplete?

Would they still have gone if they knew all that would lie ahead?

Here's what I think happens . . .

I think we get left to roam through rough terrain because sometimes the war has to happen. Because sometimes we need to be alone with our insecurities so we can realize that we're the only ones who can really fight them. Because sometimes we need to understand that we can either spend our entire lives following fear around in circles . . . or we can move forward, one foot in front of the other, and make our way through the desert.

But here's what else I think happens out there . . .

I think God happens.

Amid the blowing sand and the scorching sun and the miles of isolation, I think there is a whisper: "This way, child . . . eyes over here. Because in case you forgot, I'm the one who brought you here in the first place, and I'm the one who will bring you through it."

Until eventually it happens, a showdown happens . . .

Us and our deepest fears. Staring each other in the face.

Winner takes all.

If you're out there right now, feeling lost in the wilderness, please know this: you're not alone. I may not be standing next to you, but I am fighting with you, tackling demons of my own.

So let's do this. We've got a battle to win.

I'll see you in the Promised Land.

You are enough.

You're smart enough. You're funny enough. You're strong enough. You're kind enough. You're tough enough. You're tall enough. You're bold enough. *You're talented enough.* You're brave enough. You're responsible enough. You're worth enough. You're popular enough. You're lovable enough. **You're intelligent enough.** You're good enough.

You're doing enough. You're giving enough. You're being enough.

You are enough.

It's December 31st. I can't help but look up tonight. To patiently wait for the new year to sweep over me while the old one drifts away. I can't help but reach up and try to touch all that awaits.

This past year spent in the wilderness was a period of time that took my soul, stretched it in a thousand different ways, and molded it into something new.

It was the year defined by relationships and by adversity.

It was the year in which I started to see my value: as an artist, as a friend, as a person finding her way in this life.

It was the year that I realized meeting people is better than chasing people and that my own opinion of myself matters more than someone else's opinion of me.

It was the year I discovered what is truly worth fighting for, and it was the year I realized that one of those things was me.

It was the year I made some beautiful new friends and said goodbye to some of my oldest ones.

It was the year of heart-wrenching obstacles and unexpected joy.

It was the year of bright new futures and painfully hard pasts.

It was . . . the very essence of life.

I think there are often times when we desperately wait for the day to come when we can bid farewell to the moments that brought us to our knees. We want to shut the doors and turn our backs and close our eyes. And that's okay. But before we do that . . . let's not forget what it all means . . .

We did it.

We endured and we surpassed and we survived and we conquered and we fought and we climbed and we reached and, most of all . . . we lived.

The year may have been hard for some of us. The year may have been more than expected for some of us. The year may have been an immense struggle for some of us.

But refuse to let this last night pass without recognizing what the year has shown you . . .

You were stronger than any obstacle that came before you.

We all were.

Tonight, may you breathe deep . . . may you love hard . . . may you wish well.

May you look up as a new year passes through time, and may you find comfort in knowing that, whatever came your way this past year, you came at it with even more.

May your strength be your solace.

ACKNOWLEDGMENTS

Writing can be such a strange beast sometimes. While the words tend to come out in complete isolation, no writer is ever an island, least of all myself.

First and foremost, thank you to my husband, who has always believed that words were my North Star and would always lead me home. It takes immense patience to love a writer sometimes, and no human has loved me better than this man. And thank you to my children, who always remind me that there is so much beauty in chasing your dreams and who graciously give me the space to chase my own.

To the amazing friends who have cheered me on from the very beginning, through the deepest trenches, and as I crossed the finish line: Victoria Spofford, Charlene Hoekstra, Chelle Nicole Majeski, Devon Takenouchi, Rosie Leonard . . . Your support, check-ins, and encouragement mean more than I can say.

To Heather Smyth and Roberta Weston, thank you for holding space for me during some of my most uncertain times, for reminding me that my purpose in this world matters, and for always helping me find my way back to that purpose.

To Marilyn Le Lorrain, your grace and your courage in the face of your darkest hour have been among the most inspiring things I have ever witnessed. Thank you for allowing me the privilege of walking through this life with you and for always being one of my biggest cheerleaders.

To my Round Table family, thank you will never be enough. Thank you to Leeann Sanders and Kristin Zaleuke Westberg for believing in this book from the very beginning and for being incredible friends along the way. Thank you to Sarah Byrd for speaking life into me throughout this entire process. Thank you to Malary Hill for holding my heart for this vision in the palm of your hands and for protecting it with truth, love, and grace. Thank you for inspiring me with your own exquisite talent and for lending your beautiful words to the back cover of this book. Thank you to Kathy Catmull for being the most wonderful and generous editor, for bringing her magic to the table and making this entire book better. Thank you to Adam Lawrence for proofreading and bearing through all of my Canadianisms! Thank you to Christy Bui for her absolutely beautiful cover design, and thank you to Sunny DiMartino for bringing this entire book to life with her brilliance in layout and design.

Thank you to James Cook, Lizzie Vance, Keli McNeill, and Agata Antonow for their encouragement and excitement when I needed it most.

Thank you to Jennifer Stark for gifting me with the handwritten poster reminding me not to become my own biggest obstacle.

Thank you to Sarah and Gord Marriage for allowing me to photograph their wedding and inviting me into one of the most inspiring love stories I've ever experienced.

Thank you to La Machine for bringing Kumo and Long Ma into our lives and forever making it more magical.

And thank you to my beautiful online community, who have rallied around these words and made them what they are today. Thank you for always giving our collective vulnerability a safe place to land.

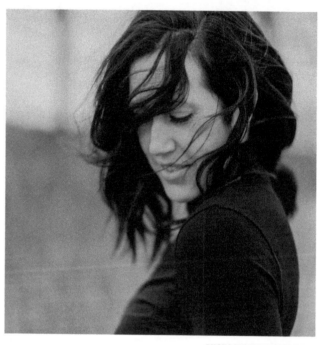

PHOTOGRAPHER: JESS JIANG

Genevieve is full-time writer and photographer living in Ottawa, Canada, with her husband and two children. Her first memoir, *Her Own Wild Winds*, was released in September of 2016, and her work can also be seen in publications such as *The Good Mother Project*, Oprah.com, *Love What Matters*, and *Her View from Home*. She is currently utilizing her skills as a writer, editor, and writing coach with Round Table Companies to help others bring their own beautiful stories to life.

www.gengeorget.com

ENDNOTES

1 T. S. Eliot, *The Cocktail Party,* in *The Complete Poems and Plays, 1909–1950* (New York: Harcourt Brace & Company, 1980), 385.

2 Mitch Albom, *Have a Little Faith: A True Story* (London: Sphere, 2009), 212.